THEN & NOW

QUEENS

Opposite: This is one of the first aerial views taken of Queens County. Measuring 15 miles east to west and 18 miles north to south with 121 square miles overall, the majority of the borough is still dominated by marshland and farms in this 1933 photograph. Clearly marked are the main arteries, which include Northern Boulevard, Roosevelt Avenue, Corona Avenue, and Queens Boulevard. The major highways have yet to appear. In the center of the image is the huge ash mound of the Corona ash dumps known as "Mount Corona." (Courtesy of the Queens Borough Public Library, Long Island Division, Queens Chamber of Commerce Collection.)

THEN & NOW

QUEENS

Jason D. Antos

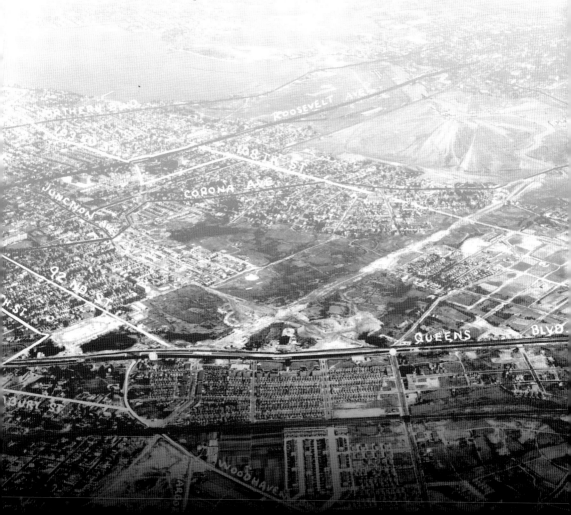

To the young writers and historians of New York City.

Copyright © 2009 by Jason D. Antos
ISBN 978-0-7385-6308-4

Published by Arcadia Publishing
Charleston, South Carolina

Printed in the United States of America

Then and Now is a registered trademark and is used under license from
Salamander Books Limited

Library of Congress Control Number: 2008925020

For all general information contact Arcadia Publishing at:
Telephone 843-853-2070
Fax 843-853-0044
E-mail sales@arcadiapublishing.com
For customer service and orders:
Toll-Free 1-888-313-2665

Visit us on the Internet at www.arcadiapublishing.com

On the front cover: On the southeast corner of Main Street and Broadway (Northern Boulevard) was the Revolutionary War–era structure Ye Olden Tavern. It was turned into the Fountain House by Jacob F. Haubeil, who purchased the tavern in 1885. "My inn is the only one on Long Island that George Washington did not sleep in," said Haubeil. In 1918, the tavern was demolished. In the late 1980s, a glass building with a design inspired by modern-day Japan was built in its footprint. Business signs in English, Korean, and Chinese are a reflection of Queens' multicultural community. (Courtesy of the Queens Borough Public Library, Long Island Division, J. D. Willis Collection.)

On the back cover: With the grade crossing and the old Main Street Flushing station now eliminated, the new Long Island Rail Road overpass, looking east, is shown near completion. The first electric trains began using the new overpass on October 21, 1913. The Flushing Institute can be seen in the background. The building at right on the corner of Madison Street (now Forty-first Avenue) is H. K. Lines Coal and Wood Masons' Materials. The Flushing branch of the Corn Exchange Bank stands on the left. (Author's collection.)

CONTENTS

ACKNOWLEDGMENTS

This work on the great borough of Queens was made possible by individuals who live in the neighborhood as well as the outer counties of Long Island. Thanks goes to James Driscoll and Richard J. Hourahan of the Queens Historical Society, everyone at the Queens Borough Public Library Long Island Division, Alison McKay at the Bayside Historical Society, and Wally Borger from the Suffolk County Historical Society. Thanks to my parents and family for their support and also to Erin Vosgien. Unless otherwise noted, all modern images were taken by the author and unaccredited historic images are part of the author's collection. Lastly, I would like to acknowledge the works of leading Queens historian Vincent F. Seyfried and a long-forgotten early-19th- and 20th-century New York historian named Sarah Comstock, whose epic book *Old Roads from the Heart of New York*, published in 1915, was a great inspiration for writing this book.

INTRODUCTION

Around 60,000 years ago, the territory that would become Queens and Greater Long Island was created by an enormous glacier that descended from southern Connecticut. Known as the Wisconsinan glacier, it created many different landforms. The North Shore, for example, contains many bays and harbors, especially in the western section. The northernmost neighborhoods are separated from one another by peninsulas called "necks," for example, Little Neck and Great Neck. The glacier also created large and small hills with swamps and ponds in between. The South Shore is known as an outwash plain. Dominantly flat and made of mainly sand and gravel, it slopes toward the sea. This difference in the island's geography was a result of only the North Shore being covered with ice.

The borough was inhabited by prehistoric creatures as well. Five molar teeth and a few bone fragments, including an ivory tusk from a young mastodon, were discovered by workers in 1858 while dredging a pond at Baisley Pond Park in Jamaica.

Queens is bounded on the west by the East River, the borough of Brooklyn from the southwest, the Long Island Sound from the north, the Atlantic Ocean from the south, and Nassau County from the east.

Queens was first inhabited by a division of the Algonquin Nation called the Matinecock. The first European settlement was made by the Dutch in 1636 near Flushing Bay, followed by the four major establishments of Newtown (1642), Far Rockaway (1644), Flushing (1645), and Jamaica (1656).

The settlement of New Netherlands did not extend much beyond western Queens because the Dutch could not find enough immigrants to occupy the vast region of eastern Queens and Long Island. In 1643, British settlers escaping persecution in Connecticut were given a deed by the Dutch for the purchase of Hempstead, making it the first European settlement in what was then eastern Queens. Wanting to keep the Native Americans off their lands, the Dutch granted more and more patents allowing the English to establish numerous and successful farming communities.

The first English settler to arrive was Richard Brutnall. On July 3, 1643, he received a grant of over 100 acres on the east side of Dutch Kills near present-day Long Island City. Soon after, the first group of English settlers to arrive was led by the Reverend Francis Dougherty.

The local Native American tribes of the Matinecock, Algonquin, Reckowacky, Jameco, and Mespeatches or Maspeth lived in harmony with their new neighbors. However, in February 1643, a group of Dutch farmers killed a few natives in a greedy land dispute and provoked the first Indian War.

In 1655, a second conflict occurred, causing the Dutch to retreat back to New Amsterdam (Manhattan Island) by order of Gov. Peter Stuyvesant. In 1656, an Englishman named Thomas Hicks dealt the Matinecocks a deadly blow. He led a band of armed white men with muskets against the Native Americans and drove them from their settlement. This final battle was fought on the present site of the Little Neck–Douglaston branch of the Queens

Borough Public Library, at Marathon Parkway and Northern Boulevard. Agawamonom and his warriors faced the white man's guns, and here the Matinecock were slaughtered until only women, children, and a few old men were all that remained of what was once the largest of all the Long Island tribes. The settlements came under English control in 1664, when Dutch ruler Peter Stuyvesant surrendered to an English force acting for the Duke of York.

On November 1, 1683, Queens County was established as one of the 12 counties of the province of New York and named after Catherine of Braganza, the queen consort of King Charles II. Catherine of Braganza, 1638–1705, married King Charles II in 1662. When New Amsterdam came under British rule, Charles renamed the land New York after his brother the Duke of York, and Queens County in honor of Catherine. He also named Kings County (Brooklyn) after himself. The population of Queens at this time was approximately 5,000.

For its first 250 years, the land of Queens remained a vast and open terrain of farmland and swamps. Even as late as 1890, most homes in the area did not yet have electricity and only those roads that passed through major towns like Newtown, Long Island City, and Flushing were paved.

With the expansion of the Long Island Rail Road (founded in 1834) in the 1870s, Queens began to see the first signs of progress. Hospitals, a police department, and other public services began to appear. Before the coming of the railroad, Queens had only one post office. Queens' industrial age took root in the late-19th-century factory towns like Woodhaven, which produced metal; College Point, where Conrad Poppenhusen's American Hard Rubber Company reigned; and also Steinway, home to the famous piano company.

Trolley service helped people move within the borough quicker than the stagecoach, which still remained a popular way to travel. It was a scene truly out of the old west with the Manhattan skyline dominating the background. On January 1, 1898, Queens County separated from Greater Long Island and became a part of New York City in what was known as the great consolidation, which included Brooklyn, the Bronx, Staten Island, and Manhattan.

Queens did not emerge from this Victorian-era way of living until the single most important day in the borough's history, the opening of the Queensboro Bridge on March 30, 1909. Queens was now open to the world. The wide-open farmlands were quickly purchased by developers and turned into thriving communities. Before the opening of the bridge in 1909, Queens had a population of 140,000. By 1920, it had grown to over a million.

New neighborhoods like Jackson Heights, Forest Hills, and Astoria were created out of barren fields and valleys. As of the 2000 census there are 2,229,379 persons living in the borough.

Queens has been the site of major social and historical progress. The Flushing Remonstrance, the first document granting the right of religious freedom, speech, press, and assembly, was signed by 30 local residents at the Quaker meetinghouse in the heart of Flushing on December 27, 1657. This document was created over 100 years before the Constitution.

Today buildings of great architectural achievement and historical importance, including old trolley lines, railroad stations, and homes of the rich and famous, are demolished and replaced with modern cookie-cutter structures. Much has been done to protect the borough's heritage through landmark designation. This has been only moderately successful.

In their book *Historic Preservation in Queens*, Jeffrey A. Kroessler and Nina A. Rappaport summarized the future of the borough's historic neighborhoods: "As for Queens we ask, 'What price progress?' Demolition, like extinction, is forever."

Jason D. Antos
Whitestone, New York

WESTERN QUEENS

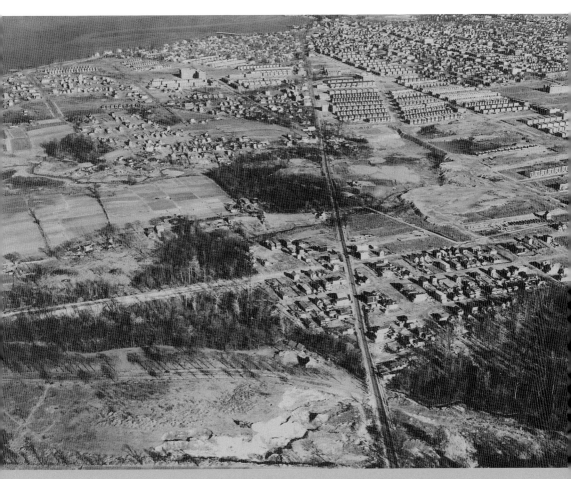

The saga of Queens County began on its western shore directly across from Manhattan Island when the first settlement of Dutch landed here in 1640. Dutch Kills was the first community settled on Newtown Creek in 1642. Astoria, seen in this aerial photograph from 1928, shows only two major roads cutting through a rocky landscape covered with trees and farms. To the west, Long Island City can be seen at the beginning stages of urbanization. (Courtesy of Fairchild Aerial Surveys.)

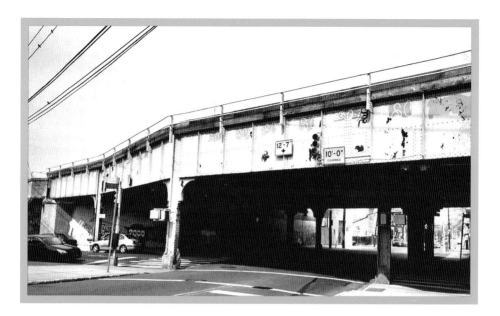

This is the oldest-known photograph of Woodside taken in the winter of 1871–1872. The village is less than five years old. The Flushing-bound steam locomotive crossing Fifty-eighth Street and Thirty-eighth Avenue is called the *New York* of the Flushing and Woodside Railroad. To the left is the station, and A. P. Riker's real estate office is on the right. In 1915, the tracks were elevated and the station house eliminated. Today graffitied walls conceal the once-picturesque rural setting. (Courtesy of the Queens Borough Public Library, Long Island Division, Illustrations Collection-Woodside.)

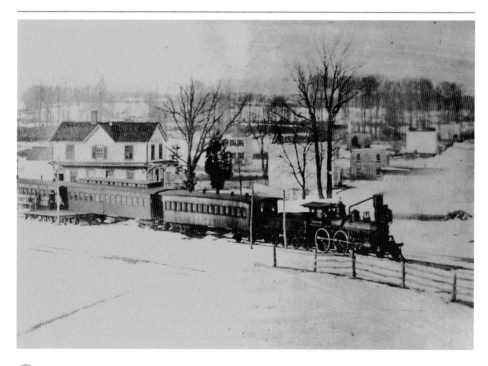

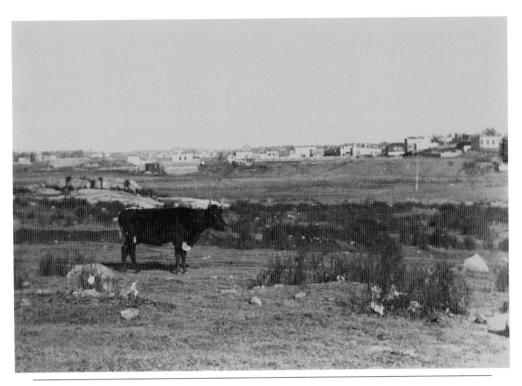

Shown here is a cow standing in the middle of a vast open terrain stretching miles in either direction covered with dirt and granite outcroppings. This amazing view, taken in 1893, looks eastward from Vernon Avenue (Vernon Boulevard) across Dutch Kills Meadows to the emerging Long Island City. The meadows were gradually filled in from 1890 to 1920 with asphalt and new streets. Queens' first skyscraper, the Citicorp Tower, was built in the last open space of Long Island City in 1990. (Courtesy of Joseph R. Brunelle, Van Riper Collection.)

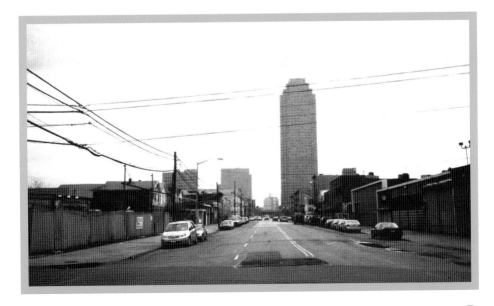

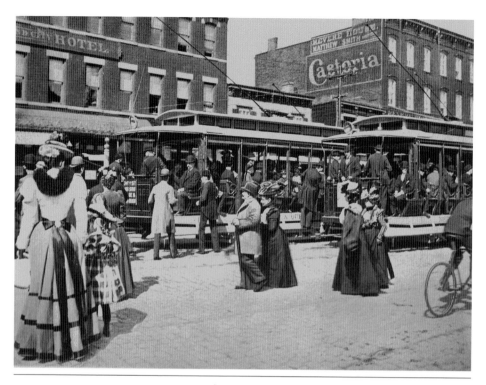

Long Island City is pictured in the year of consolidation, 1898. People in gorgeous Victorian-era dress board electric trolleys near the Thirty-fourth Street ferry port at the foot of Borden Avenue. Over 50,000 people a day made this Manhattan–Queens commute. The building to the back left is Tony Miller's Hotel. Constructed as a three-story building in 1881, it catered for 35 years to the New York City elite, including Pres. Theodore Roosevelt. The structure was reduced to two stories and today is the Waterfront Crabhouse. The ferry port and trolley lines have disappeared. (Courtesy of the Greater Astoria Historical Society.)

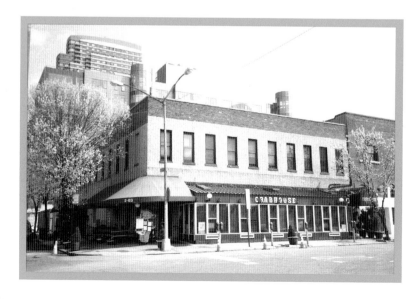

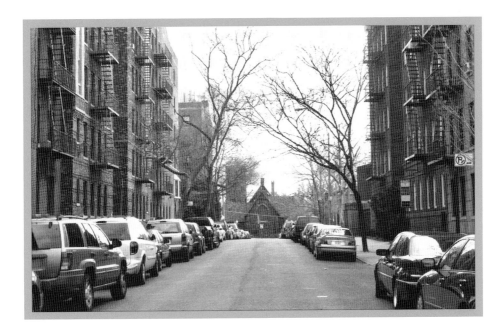

Temple Street (Thirtieth Road) east of Astoria Boulevard is pictured in 1900. Founded in 1839, Astoria was named after fur trader John Jacob Astor. The Episcopal Church of the Redeemer, founded in 1866, can be seen on Crescent Street. The raised sidewalks and private homes on either side of the street have been leveled and replaced by World War II–era apartment buildings.

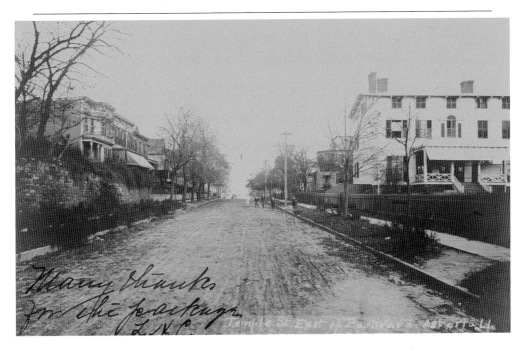

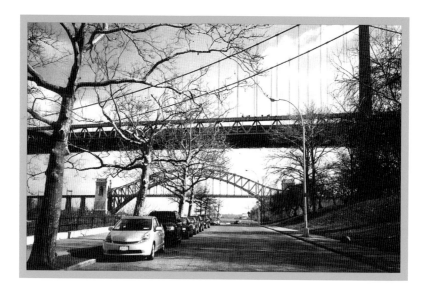

This is a view of Astoria Park around 1905 (then known as East River Park), looking north on Shore Road (Shore Boulevard). A group of men fish off a small stone jetty and enjoy a surprisingly calm Hell Gate River. Astoria Park remains as a place for quiet relaxation but now offers two additions. The small stone pier has long been replaced by the Hell Gate Bridge and Triborough Bridge. Shore Boulevard and the coastline have been elevated and widened.

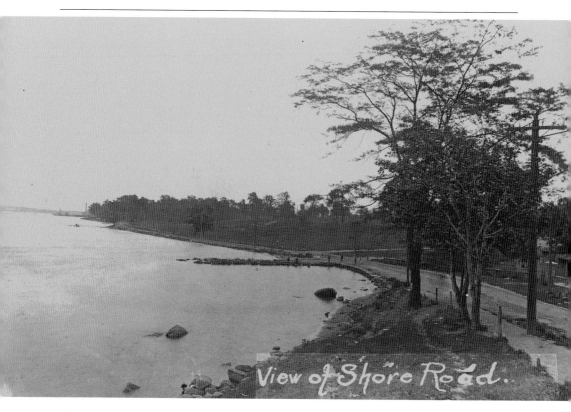

View of Shore Road..

In this never-before-seen image, schoolchildren from Public School 88 in Ridgewood hold one of the largest heads of cabbage raised in the school's war garden. The garden covered a tract of one and a half acres and yielded over $500 worth of produce in 1918. The beautiful Victorian-era schoolhouse can be seen at the top of the hill on the right. A modern-day version now stands at 6085 Catalpa Avenue. The new building's style, a less ornate brick finish, is typical of all New York City public schools built after World War II. (Photograph by J. H. Rohrbach/ Department of War.)

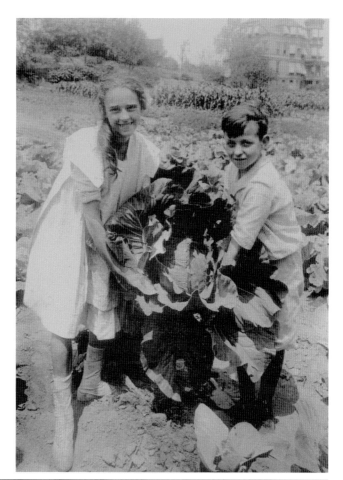

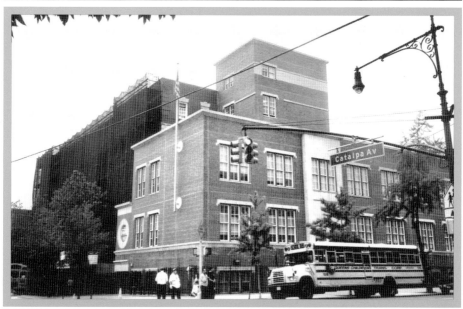

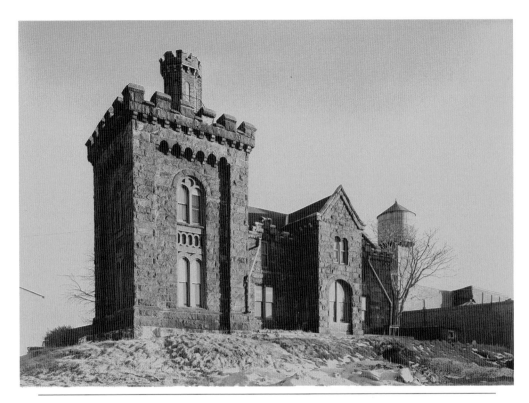

Located at 4316 Vernon Boulevard was Bodine Castle of Long Island City. Named after its owner, John Bodine, an official of the Long Island Savings Bank, this beautiful villa designed in the Gothic Revival fashion was built in 1851 overlooking the Manhattan skyline. It was demolished in 1966 by the city's power company, Consolidated Edison, and turned into a power substation. This taxi-repair garage was built in its place after the substation was relocated in the 1970s. The loss of Bodine Castle is an example of the forever-changing landscape of Queens. (Courtesy of the Library of Congress.)

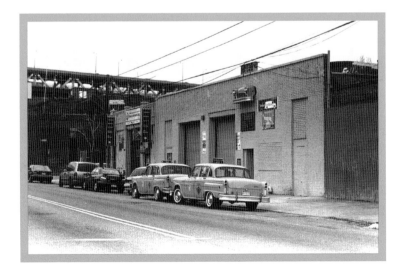

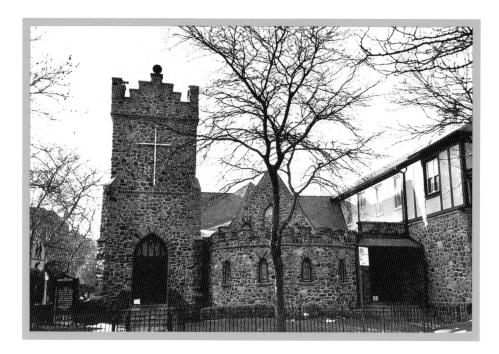

The Elmhurst Baptist Church is shown here in Elmhurst in 1908. Located at 8737 Whitney Avenue and Judge Street, the unique beautiful stone house of worship still remains active to this day, including the row houses seen on the left. Elmhurst was established in 1652 by the Dutch, who called it Middleburgh.

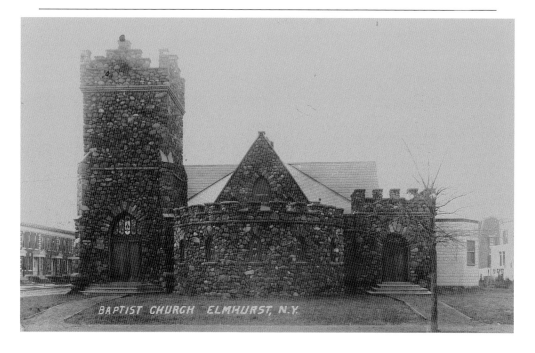

BAPTIST CHURCH ELMHURST, N.Y.

This view is looking north on Flushing Avenue in Ridgewood around 1900 on the border of Queens and Brooklyn. In the background on the right is the Vander Ende-Onderdonk home, the oldest Dutch Colonial stone house in New York City built in 1660. This image shows another great example of rural farming in Queens. However, signs of industry had already started to show. The Vander Ende-Onderdonk house, now a landmark, was used to determine the official boundary between the former district of Newtown in Queens and Bushwick in Kings County (Brooklyn). (Courtesy of the Library of Congress.)

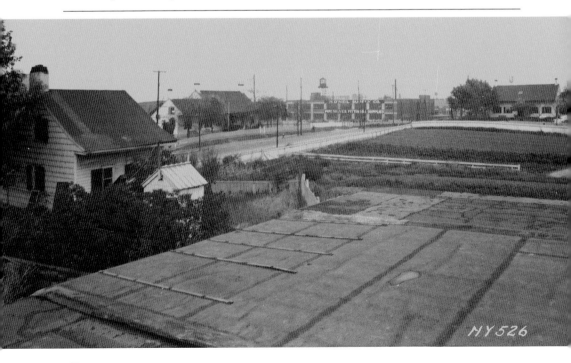

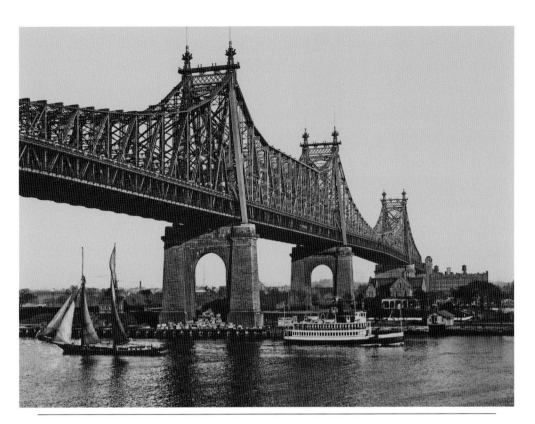

The first bridge to link Queens with Manhattan, the Queensboro Bridge, designed by Henry Hornbostel and Gustav Lindenthal, started construction in July 1901 at a cost of $17 million. The span opened on March 30, 1909, ending the isolation of Queens. This image was taken from East Fifty-fifth Street in Manhattan looking toward Queens. The beautiful Colonial home belongs to the prison warden on Blackwell's Island (Roosevelt Island), just south of the bridge pier. Today both prison and home have been replaced by apartment buildings.

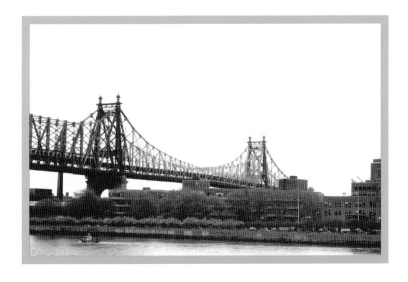

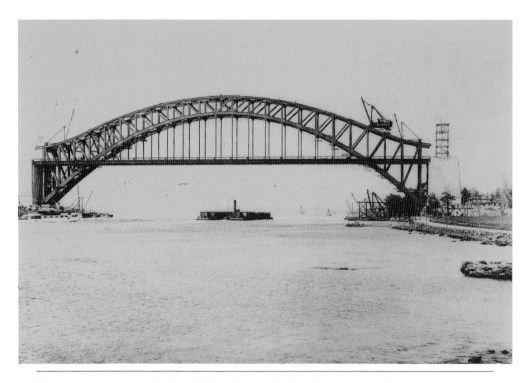

The construction of the Hell Gate Bridge is seen in early 1916. Designed by Gustav Lindenthal, the span has just been completed over the Hell Gate River as cranes put the finishing touches on the arch, the biggest in the world at the time. The bridge will service the New York Connecting Railroad. Navigated by European fur trader Adrian Block in April 1614, the origin of the river's name comes from *hellegat*, which means "bright passage" in Dutch. The bridge still services cargo and Amtrak trains.

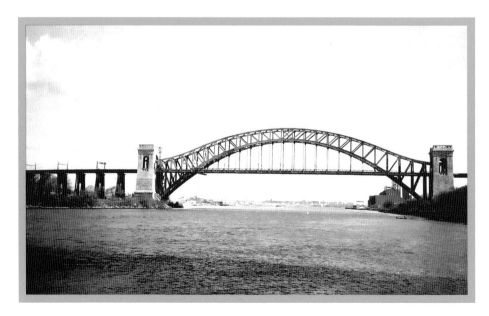

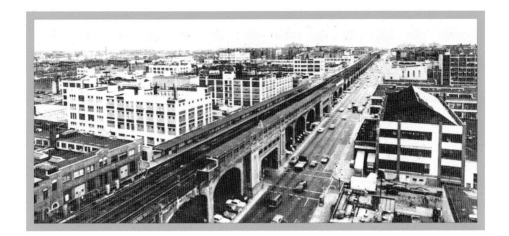

On January 12, 1917, Thompson Avenue (Queens Boulevard) was a narrow two-lane road with trolley tracks on either side as it cut past the new Rawson Street (Thirty-third Street) station on the Interborough Rapid Transit Subway Main Street Flushing line. Sunnyside lies open and underdeveloped all the way out to Woodside in the distance. These acres of barren land gave way to the industrial boom that followed World War I and the opening of the Queensboro Bridge. The fact that this desolate area developed into its current state in less than a generation is phenomenal. (Historic image courtesy of the LaGuardia and Wagner Archives, Fiorello H. LaGuardia Community College, City University of New York; modern image taken by Daniel Jacino, New York Daily News.)

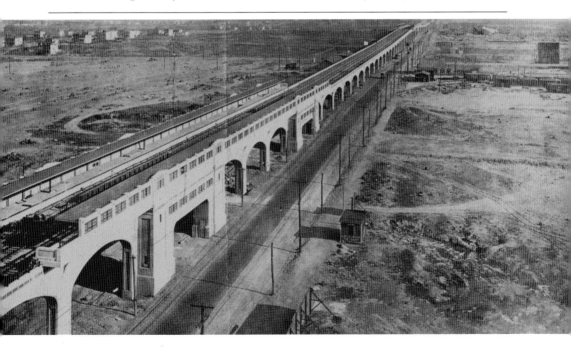

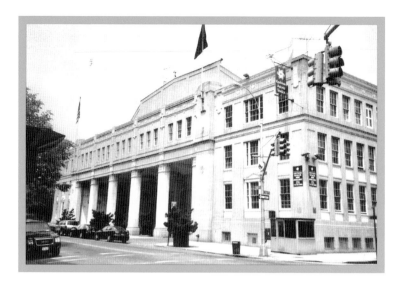

Astoria Studios, both old and new, is located at Thirty-fifth Avenue and Thirty-sixth Street. Opening in September 1920, it was built by Famous Players-Lasky Corporation (Paramount Pictures). It began by producing silent pictures, army training films, and commercials before graduating to big-budget, full-length features. In this rare image, a production crew is filming *Battle of Paris* in 1929. Locals built the film sets and acted as extras. Astoria is seen in the background. Now Kaufman-Astoria Studios, it is the largest film studio on the East Coast. (Courtesy of the Queens Borough Public Library, Long Island Division, Postcard Collection.)

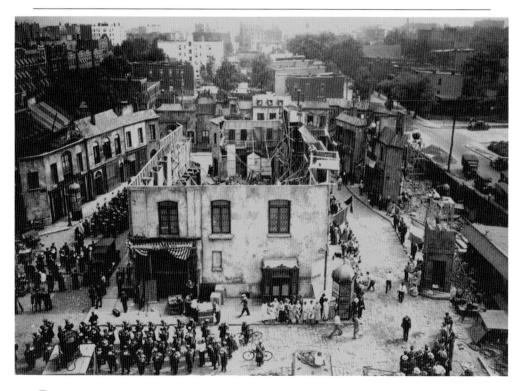

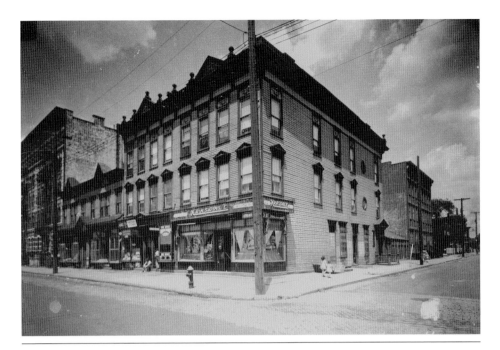

The Astoria Houses, built in the late 1880s, was a complex located on Astoria Boulevard and Third Street a few hundred feet from the East River. This image taken on July 26, 1946, shows the Krasdale food market. The old cobblestone street has been mainly covered with modern asphalt pavement. By the early 1950s, Long Island City experienced a housing boom, and this entire block was cleared to make way for a vast city housing project. The buildings still bear the same name as the former 19th-century complex.

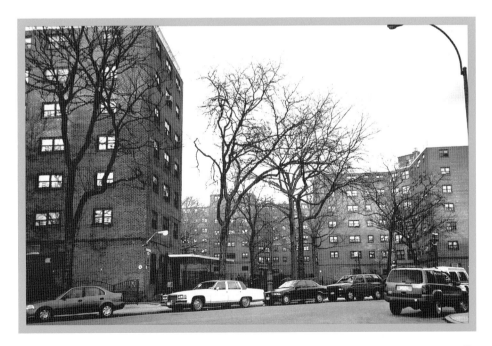

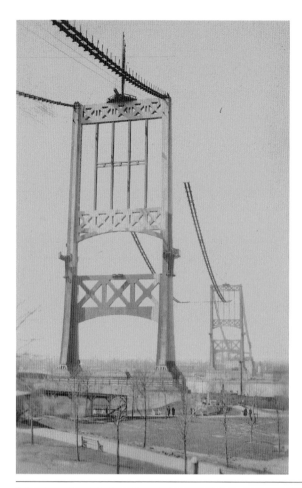

Construction on the Triborough Bridge began the day the stock market crashed in 1929. Designed by Othmar H. Ammann and Aymar Embury II, the bridge is divided into three spans connecting Manhattan, Queens, and the Bronx. The bridge opened on July 11, 1936, and cost $65 million. The towers of the main bridge are shown in this construction photograph taken from Astoria facing west toward Ward's Island. The main span measures 2,780 feet in length and 143 feet above the water. Sixty million vehicles cross the bridge each year.

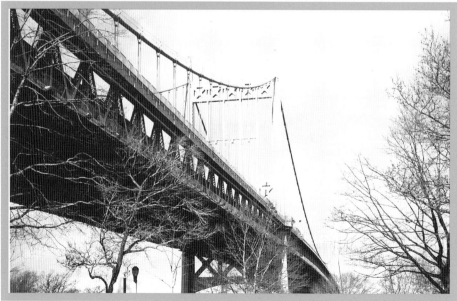

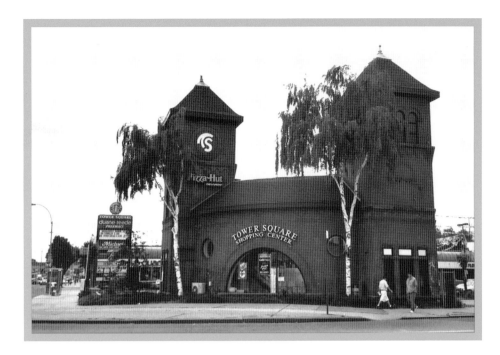

Shown here in 1934 are the Woodside streetcar barns of the New York and Queens County Railway. Built in 1896, trolleys from Flushing, College Point, Jamaica, and Long Island City were serviced here, and passengers changed cars for different routes. Used as a warehouse until 1987, the barns were destroyed to build a shopping center. The towers and former waiting room still remain on the southeast corner of Northern Boulevard and Woodside Avenue. It now houses a Pizza Hut, below whose sign retains the words, "N.Y. and Queens Co. RY. Co. Waiting Room." (Courtesy of the Queens Borough Public Library, Long Island Division, William J. Rugen photographs.)

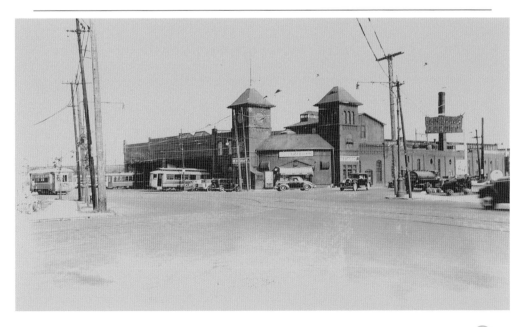

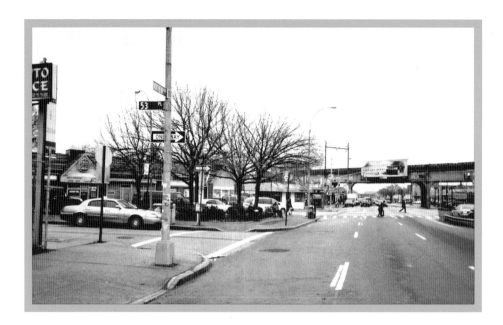

Northern Boulevard opened in July 1860 and cost $40,000 to build. Originally the Hunters Point, Newtown and Flushing Turnpike, it was a gravel and cobblestone roadbed with a tollhouse that collected a 9¢ toll from carriages. This view is looking east a few blocks from the trolley barns. The Boulevard Gardens tennis courts in Woodside can be seen at left. Now eliminated, the clubhouse, seen at back left, was converted into a small strip mall and the courts divided up into side streets and private homes.

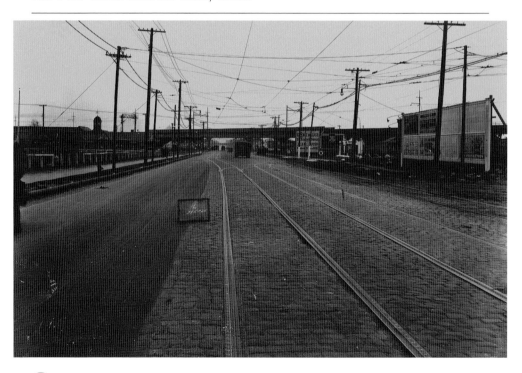

A trolley operated on the Queensboro Bridge from 1914 to 1957. It would stop at mid-span for passengers to board an elevator for Welfare (Roosevelt) Island below. Shown here is famous car No. 601. The last trolley to operate in New York City, it was shut down in 1957 after the Welfare Island Bridge was built. The upper level now has four lanes. The trolley lane is now used for automobiles. (Historic image courtesy of the collection of David Keller; modern image courtesy of the Library of Congress.)

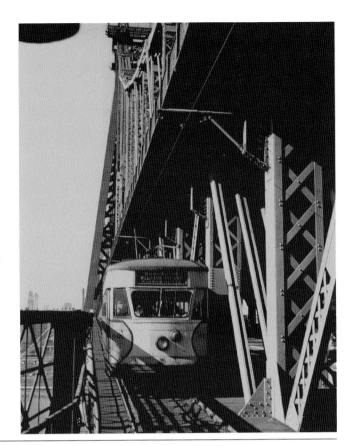

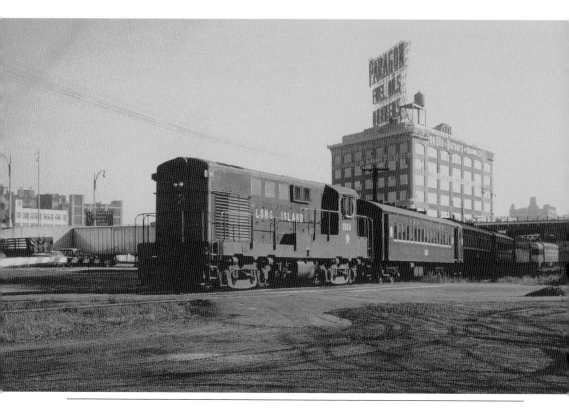

The Sunnyside Yards of the Pennsylvania Rail Road were built in the early 1900s. At the time, it was the largest rail yard in the world. The yards stretch between Thirty-ninth Avenue and Northern Boulevard. The old village of Sunnyside was relocated to accommodate the expanding yards. The warehouse, seen behind the Long Island Rail Road diesel engine, was owned by Paragon Oil. The company is now known by its current name, Texaco. Today the No. 7 line runs past the building that still bears the Paragon "ghost ad."

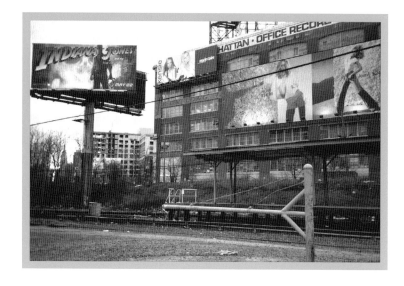

CHAPTER

NORTHERN QUEENS

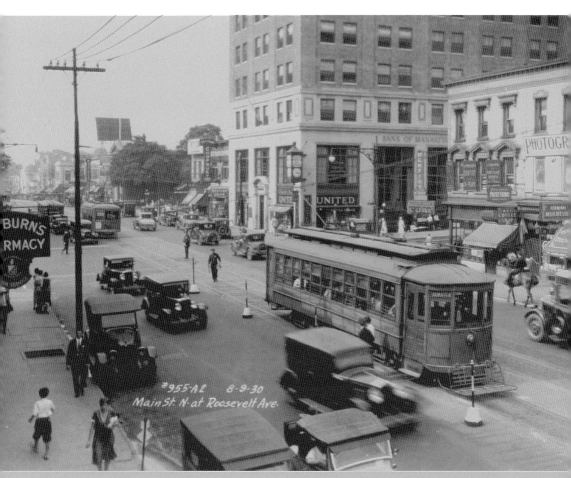

Northern Queens, including the neighborhoods of College Point, Whitestone, and Flushing, was first settled by the Dutch in the early 1640s. This amazing photograph of Flushing is looking north along Main Street on August 9, 1930. The Jamaica-bound trolley heads south while the Bank of Manhattan can been seen on the corner of Main Street and Roosevelt Avenue. (Courtesy of the Queens Borough Public Library and the New York City Department of Highways.)

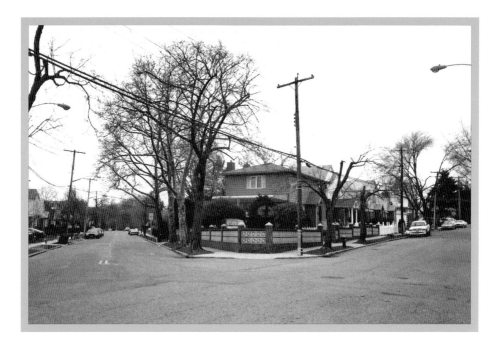

The Johannus Spronge Homestead was located on Fresh Meadows Road and Pigeon Meadow Road, which is near Flushing Cemetery. This old stone house was erected in 1662 and was lived in by British troops during the occupation (1776–1783). It was demolished in 1905 to make way for the expanding new system of side streets and planned neighborhoods.

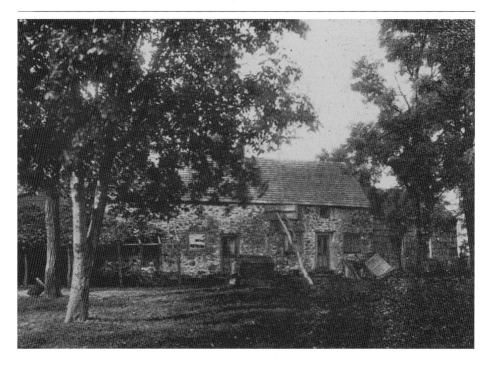

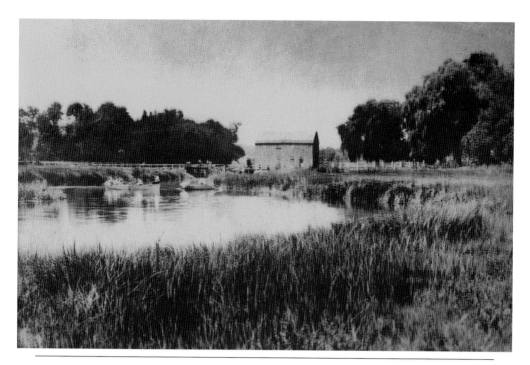

Known as Kip's, Fish's, and Jackson's Mill, this structure was first built by a Dutch settler named Warner Wessells in 1655. The Jackson homestead is located behind the mill, which was powered by a large undershot wheel used to grind wheat and corn until 1870, when Samuel Jackson became disabled. This view is looking northeast toward Whitestone. The road in the foreground is now Ninety-fourth Street and the main entrance to LaGuardia Airport. The Grand Central Parkway runs through what used to be Jackson Creek. (Courtesy of the Queens Historical Society.)

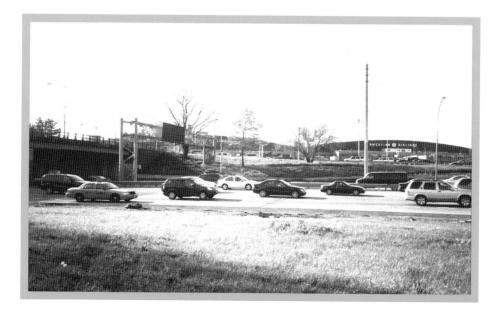

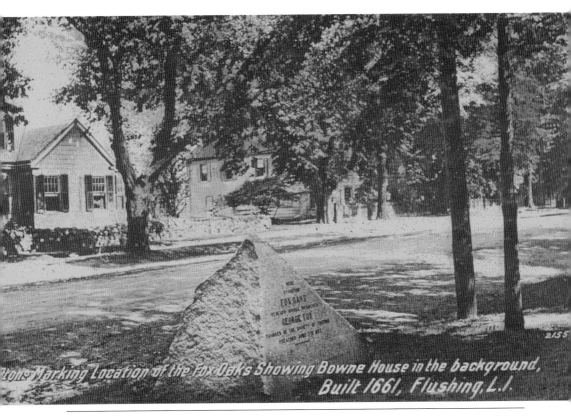

Stone Marking Location of the Fox Oaks Showing Bowne House in the background, Built 1661, Flushing, L.I.

This stone, erected in 1897 on Bowne Street, marks the location of the two large oak trees where George Fox, the creator of the Society of Friends, preached to the Quakers of Flushing in the late 1600s. The trees were destroyed by lightning in the late 1800s. To the rear is the home of John Bowne, erected in 1661. Bowne was instrumental in the creation of the Flushing Remonstrance. The stone marker remains after 111 years in its original location.

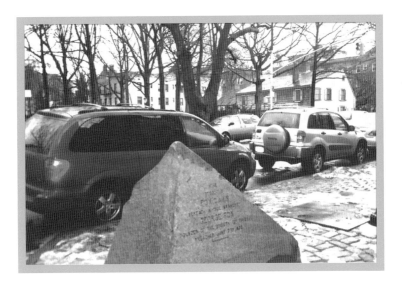

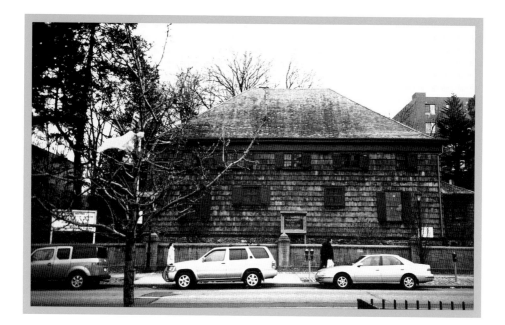

The Quaker meetinghouse, located at 137–16 Northern Boulevard in Flushing, was built by John Bowne in 1649. Active for 359 years, its members have made history by struggling against religious intolerance and slavery. This plain rectangular building was erected on a frame of 40-foot oak timbers, hewn from a single tree. Featured guests have included Pres. George Washington. The oldest house of worship in New York State and the second oldest in the nation, services are still held every Sunday. (Courtesy of the Library of Congress.)

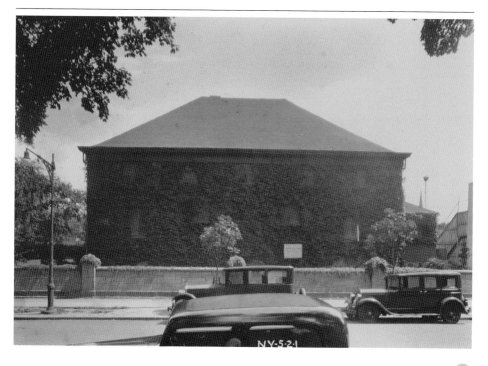

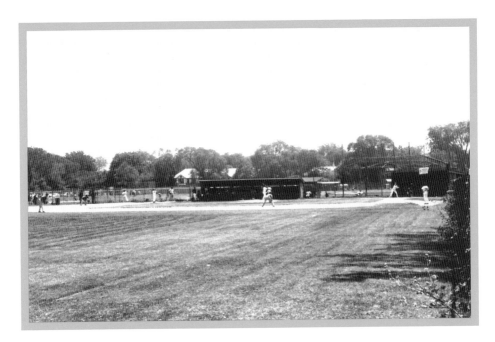

Erected in 1654 by the Riker family, this beautiful Dutch-style house stood at the foot of Eighty-first Street by Bowery Bay in what is now Elmhurst. The property had a spread of 120 acres. Originally one level, it was modified into three by succeeding owners. The house was destroyed in 1936. Today the fields of ElmJack Little League, founded in 1953, occupy the spot. Here a team plays on the Babe Ruth Memorial Field looking south toward Eighty-first Street. (Courtesy of the Library of Congress.)

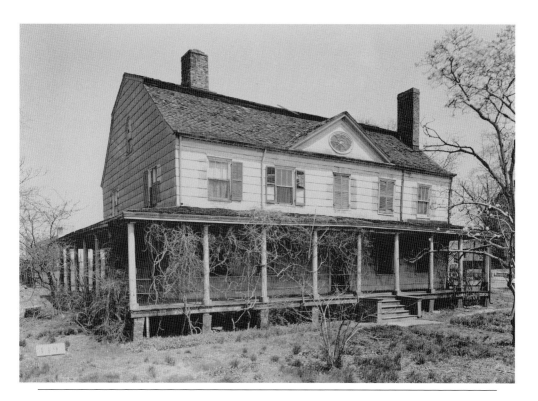

The Prince Homestead was located at the northeast corner of Bridge Street (Northern Boulevard) and Lawrence Street (College Point Boulevard). Created by William Prince in 1737, it was the nation's first commercial nursery called the Linnaeus Gardens. Pres. George Washington along with Vice Pres. John Adams visited it in 1789. Washington wrote, "I set off from New York, about nine o'clock in my barge, to visit Mr. Prince's gardens at Flushing." The nursery closed after the Civil War. Today Flushing Bridge overshadows the factories that now dominate the former nursery. (Courtesy of the Library of Congress.)

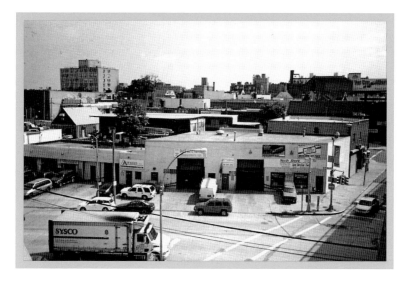

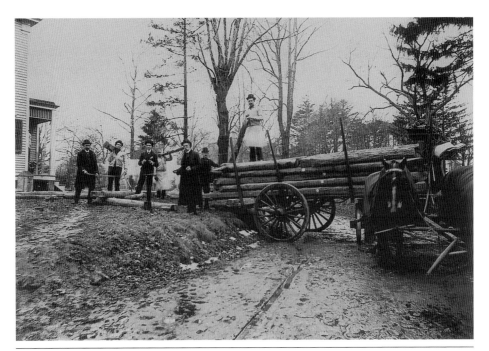

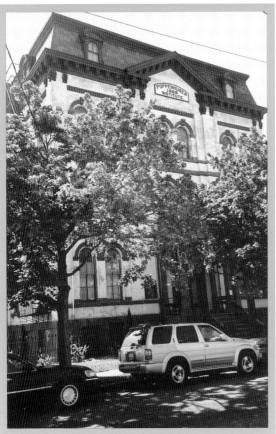

Pictured here is the removal of the original Abraham Lincoln log cabin from College Point, on February 21, 1906, where it was on display at the Poppenhusen Institute, on 114–04 Fourteenth Road. It was reerected on the Lincoln farm at Hodgenville, Kentucky, the birthplace of the murdered president. College Point was originally called Lawrence's Neck and renamed to its current title after the opening of St. Paul's College in 1835. Built in 1868 by Conrad Poppenhusen, the institute became the first free kindergarten in the United States. (Courtesy of the Library of Congress.)

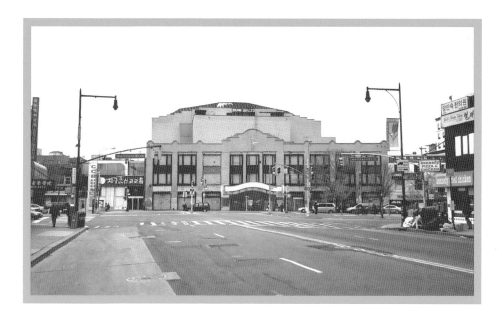

The Flushing Hotel, in 1914, was at the head of Main Street and Broadway (Northern Boulevard). John and Martin Maher purchased it in September 1853. Martin died on May 14, 1858, at the early age of 29. The mortgage was foreclosed on September 13, 1858, and the hotel was sold to Mrs. J. B. Boerum and six months later to Isaac Edward of Brooklyn. Torn down to build the Keith-Albee Theater, it opened on Christmas Day, 1928. It became the RKO Keith's movie palace and remains today as an abandoned landmark. (Courtesy of the Queens Borough Public Library, Long Island Division, J. D. Willis Collection.)

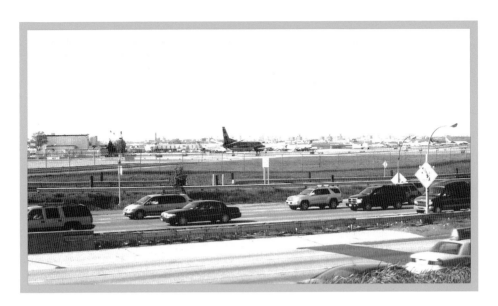

The grand pier and steamboat landing at North Beach are pictured in 1892. It was here that boats brought vacationers from Manhattan, College Point, and the Bronx. At 300 feet long and 120 feet wide, it was operated by Paul Steinhagen and Julius Kelterborn and accommodated 2,000 people. Lunches were served by attentive waiters, and a band played lively music. It is now the runway for Fiorello H. LaGuardia Airport. (Courtesy of the Queens Borough Public Library, Long Island Division, Borough President of Queens Collection.)

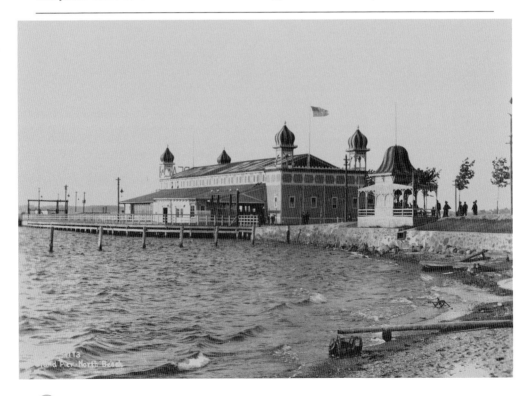

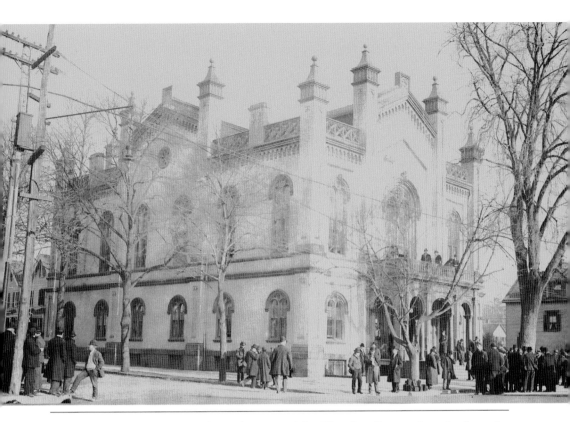

Flushing Town Hall, located at 137–35 Northern Boulevard, was the seat of government for old Flushing. It is seen here in 1916 when it was the Queens County Court House. Designed by architect William Post in the Romanesque Revival fashion, it opened in January 1864. Theodore Roosevelt spoke from the steps during his campaign for president. It remains the only town hall of its era still standing in Queens. Now the Flushing Council for the Arts, it features art, live jazz, and historical exhibits.

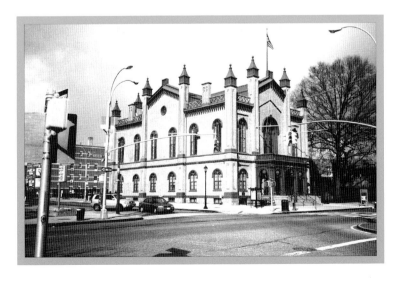

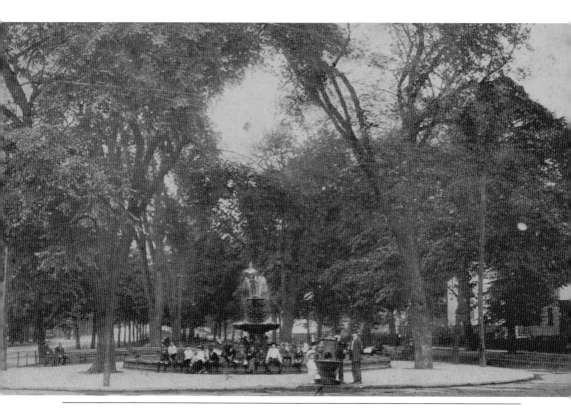

Taken in the summer of 1906, this rare postcard shows the intersection of Main Street and Broadway. Looking east, this grand esplanade featured a water fountain. Two men standing on the corner drink from a municipal drinking fountain used for both people and horses, as indicated by the basin attached to the bottom. Now the Daniel Carter Beard Square, named for the cofounder of the Boy Scouts of America, it is just a slab of concrete with a few benches overlooking traffic-jammed streets. The huge ship mast displayed at center is the Spanish-American War memorial.

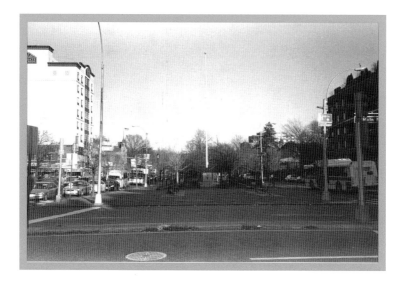

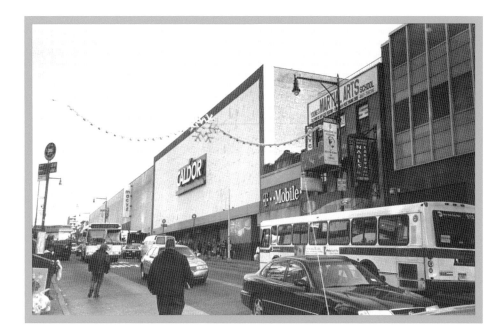

Shown here in a postcard from 1901 is Elias Fairchild's Flushing Institute. Founded in 1843 and constructed in 1828 in the Greek Revival style, the institute provided secondary schooling to the sons of wealthy eastern families, including children from as far away as South America. The school closed in 1902 and was torn down in 1925. Today, standing in its place on the southeast side of Roosevelt Avenue and Main Street, stands the abandoned Caldor department store.

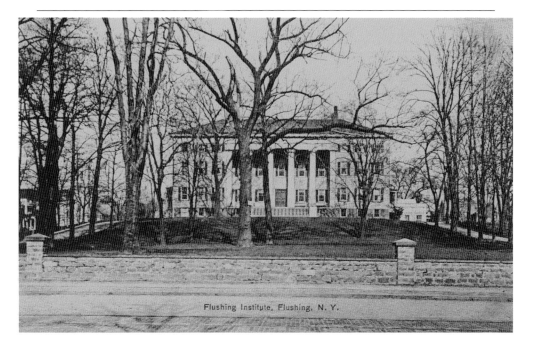

Flushing Institute, Flushing, N. Y.

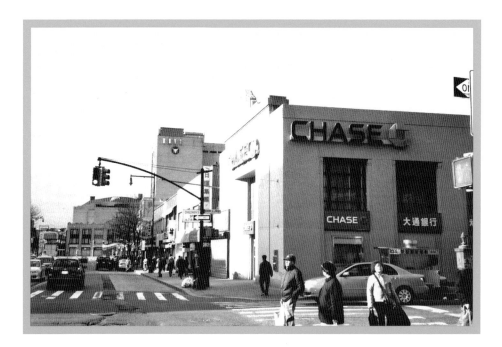

Here is the Bank of Long Island located at the corner of Locust Street (Thirty-ninth Avenue) and Main Street in 1910. The Bank of Long Island was created in order to secure control of the Flushing Bank, the Bank of Jamaica, and the Far Rockaway Bank. The beautiful ivy-covered building is now the concrete Federal-style structure that houses a Chase Manhattan Bank.

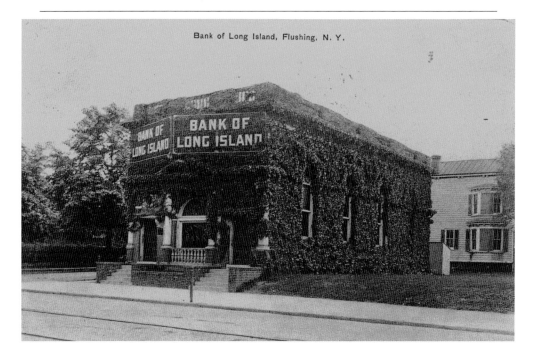

Bank of Long Island, Flushing, N. Y.

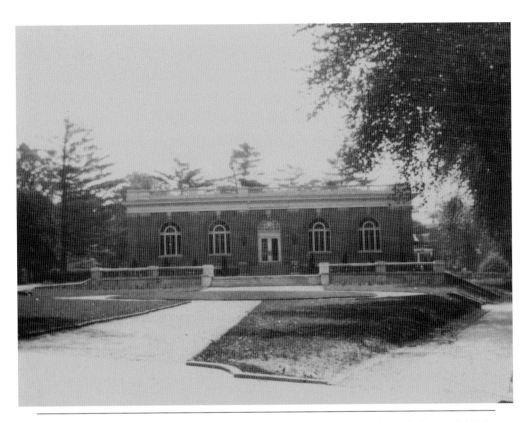

Constructed in 1904 and opened in 1906, the Flushing branch of the Queens Borough Public Library, built with money donated by millionaire Andrew Carnegie, stood at the intersection of Main Street and Kissena Boulevard. It was closed and torn down in 1957 when a new library was built and stood until the mid-1990s. It too was demolished, and this amazing glass 50,000-square-foot building designed by James Stewart Polshek and Partners opened in 1998. It is the largest branch in the borough.

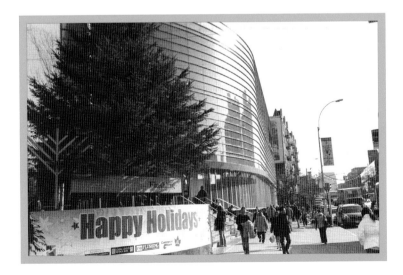

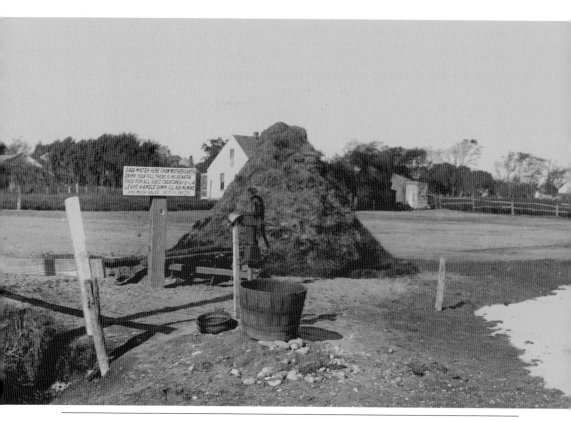

This rare image taken on the shore of Flushing Creek shows the beautiful farmland that dominated the area. The sign by the water pump reads, "Good water here from mother earth. Drink your fill there is no dearth. Free for all God's creatures on 2 feet or 4. Leave the handle down, I'll ask no more, and much oblige. Ruth N. Smith." The farm and prairies have given way to mud-covered roads that wind through asphalt and textile factories. (Courtesy of the Suffolk County Historical Society.)

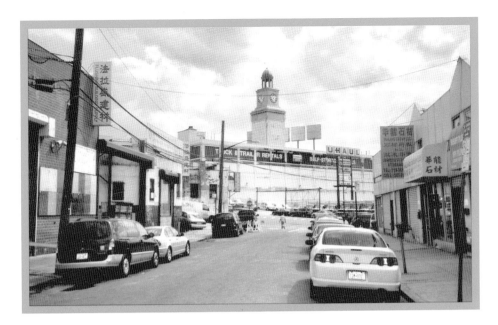

The Whitestone branch of the Long Island Rail Road entered Flushing village at this point after crossing the bridge over Flushing Creek. Here is the grade crossing at Old Lawrence Street (King Road) on July 6, 1917. The area behind the grade crossing is property of the Linnaeus Gardens of the Prince nursery. The line was abandoned in February 1932. The giant U-Haul storage warehouse, originally the W. J. Sloan Furniture Company and then the Serval Zipper Factory, stands where the train would cross the creek en route to and from Manhattan.

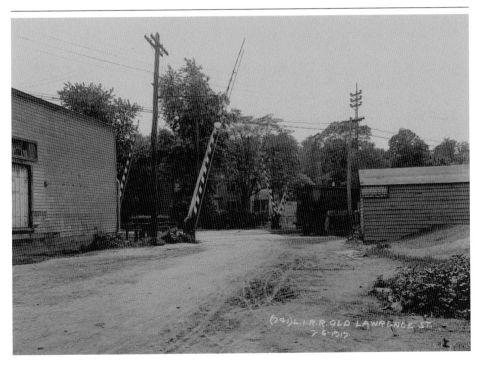

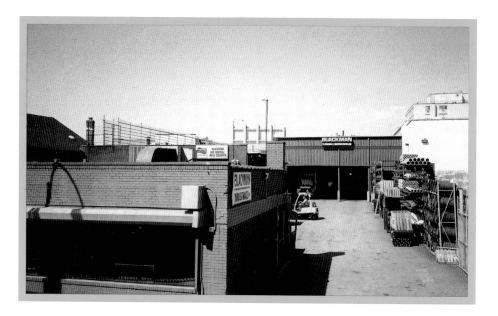

The next stop, Flushing Bridge Street station, was located north of Northern Boulevard between Collins Place and Prince Street. Erected in 1897, it contained inside toilets with running water, electric lights, and was heated by stoves. The 348-foot wooden platform also featured a newspaper kiosk. After the line was abandoned, it was completely demolished. The concrete warehouse, seen in the background to the left, still remains. Blackman Plumbing and Heating Supply now stands in the train's old right-of-way. (Courtesy of the Queens Borough Public Library, Ron Ziel Collection, James V. Osborne photographs.)

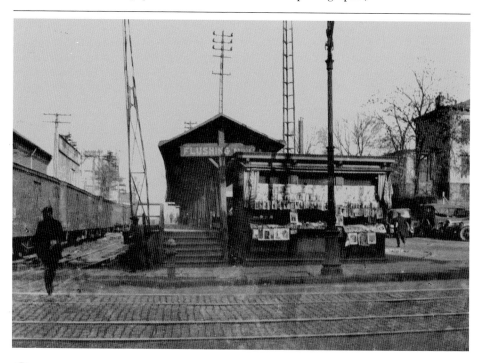

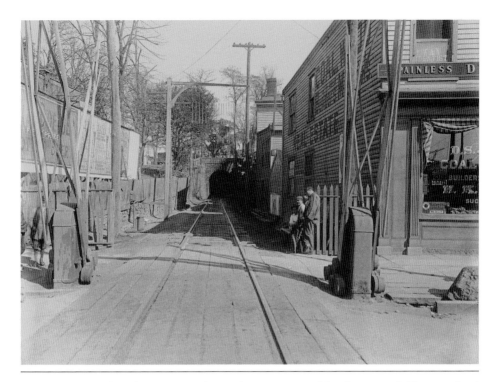

The Flushing railroad station was located on the west side of Main Street. This tunnel underneath the Flushing Institute opened on October 27, 1866. The school's principal Elias Fairchild refused to allow the North Side Rail Road to lay its tracks through the institute's grounds unless it was covered by this tunnel. He was afraid the steam engines would distract his students from their lessons. The tunnel, only one block long from Main Street to Union Street, lasted until 1913 and is now an overpass.

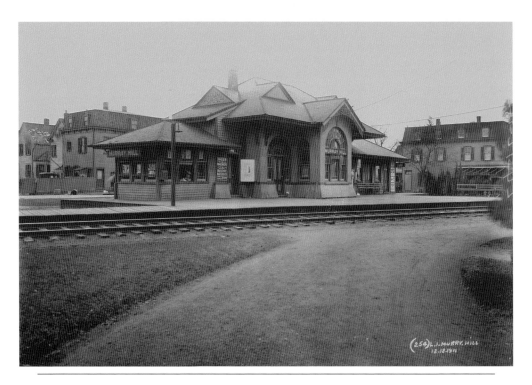

The Long Island Rail Road's Murray Hill station of the Port Washington branch was opened in April 1889. This beautiful station had a very unique exterior design. Inside it featured bathrooms, a candy store, and telephone and telegraph service. This view is looking south to 149th Place and Forty-first Avenue. The station was torn down in 1912, and the line was depressed in 1913. A simple glass canopy now covers the staircase that descends to the platform.

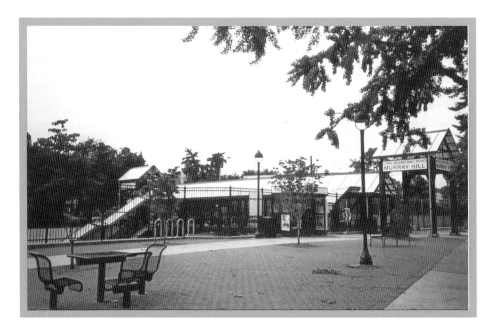

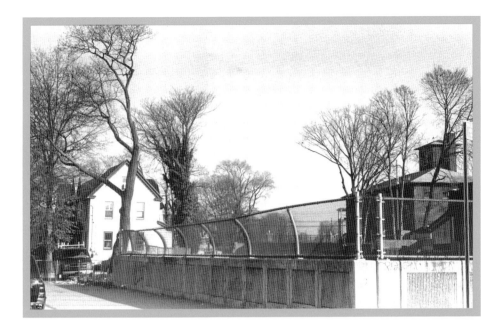

The Murray Hill Hose Company No. 4 is shown here on Forty-first Avenue and 150th Street. The horse-drawn fire brigade was still in operation even after most of the volunteer fire departments were defunct by the city and consolidated into the Fire Department of New York (FDNY). To the right of the wooden station are the watchtower and the tracks of the Long Island Rail Road. The home on the corner is easily recognizable as the only remaining structure immediately behind the former station.

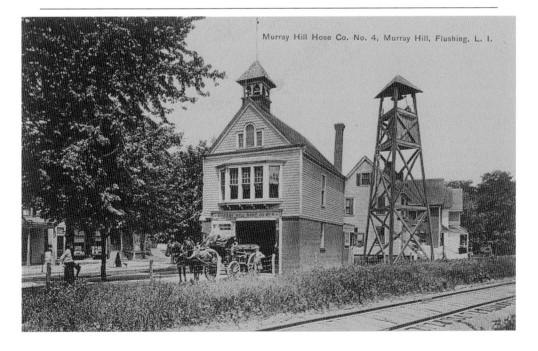

Murray Hill Hose Co. No. 4, Murray Hill, Flushing, L. I.

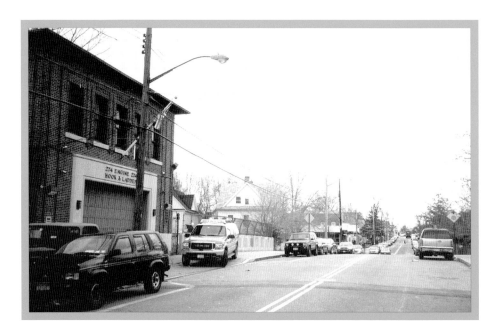

The Long Island Rail Road would travel at ground level through these grade crossings. Overgrown weeds and tall grass surround the dirt road that is Murray Street in 1910 looking north. Now it passes below street level, and the firehouse once adjacent to the station has been relocated to the other side of the overpass. Built by the Work Projects Administration in 1939, the new station house, Engine 274 Hook and Ladder, is visible on the left.

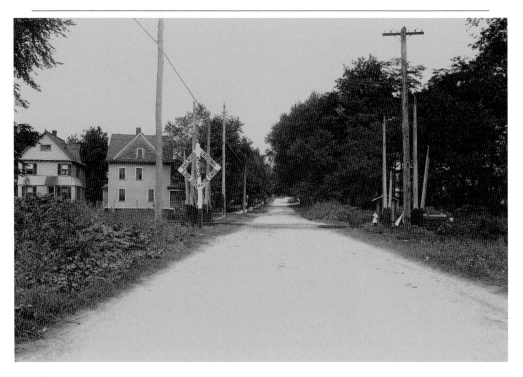

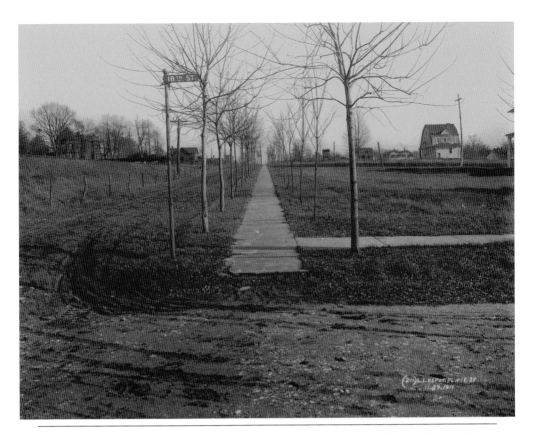

Depot Road and Eighteenth Street, now 158th Street, show an underdeveloped Flushing on November 27, 1911. Depot Road is made entirely from dirt and has been reduced to mud after a storm. A single house on the right stands alone among empty lots of land that are being sold to create the new neighborhood of Broadway. To the left are the tracks heading west to Flushing. Today that lonesome house is obscured by hundreds of dwellings lined up one after the other.

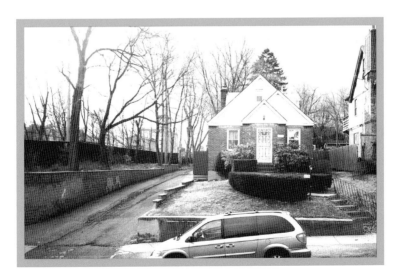

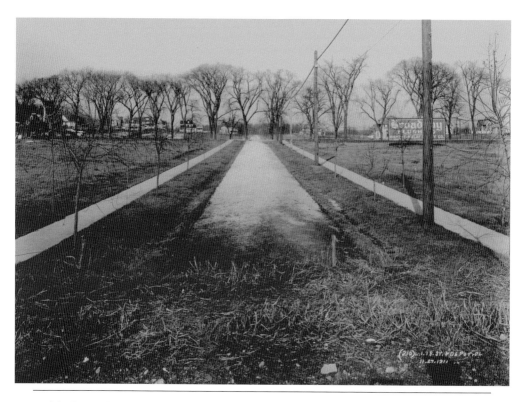

A block up looking north shows more underdevelopment in 1911. The sign on the right advertises the new subsection of Flushing called Broadway, a creation of the Rickert-Finlay Realty Company. The overpass of the railroad was built through this open land in 1912 when the grade crossing was elevated.

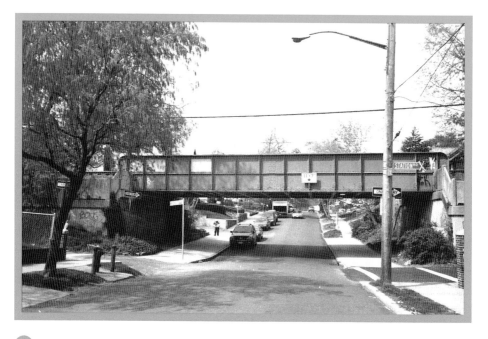

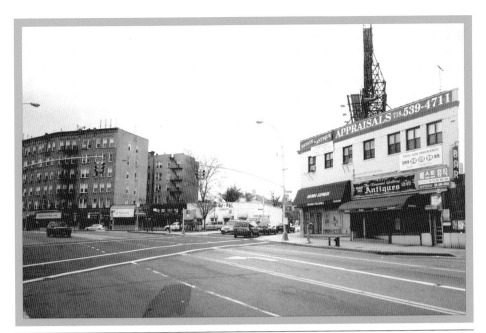

The approach to the Broadway station, which opened on October 27, 1866, is seen here crossing Northern Boulevard and 162nd Street. The building at the intersection housed the real estate offices of the Rickert-Finlay Realty Company. The grade was raised in 1912. Today people traveling down this intersection are left to deal with unusual curves and sharp turns in the road due to it being the former right-of-way for the train. (Milstein Division of United States History, Local History and Genealogy, the New York Public Library, Astor, Lenox and Tilden Foundations.)

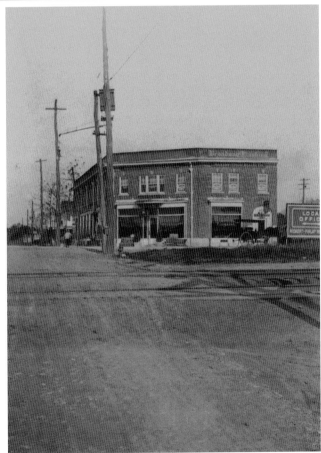

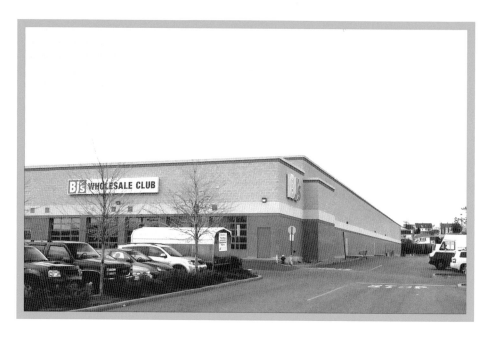

In this photograph taken on May 9, 1921, the Whitestone branch of the Long Island Rail Road passes through an open field as it approaches Malba, a subsection of Whitestone. The right-of-way posts follow alongside the tracks, which are now electrified. The open plain, which would become 142nd Street and Twentieth Avenue, is now occupied by a Target, Circuit City, and BJ's Wholesale Club. This driveway marks the train's right-of-way. (Courtesy of the Queens Borough Public Library, Long Island Division, Ron Ziel Collection.)

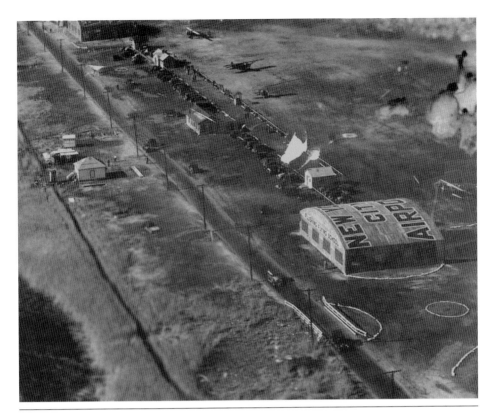

One of New York City's earliest municipal airports was located on the border of Flushing and College Point at the foot of Linden Place. Flushing Airport opened in 1927 and was known as Speed's Airport after its owner, Anthony "Speed" Hanzlick. It was the city's busiest airport until North Beach Airport, now LaGuardia Airport, opened a mile away. This aerial view from 1931 shows biplanes and the main hangars. Abandoned in 1984, the runway and hangars have now been totally reclaimed by nature.

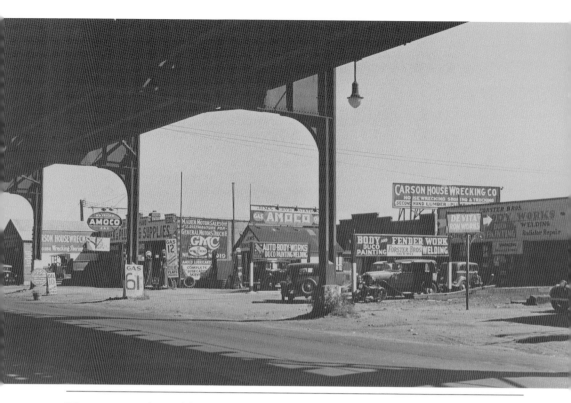

The motor works and body shops of the Iron Triangle located at Willets Point in Flushing opened in the early 1920s. It is bounded by Northern Boulevard to the north, 126th Street to the west, and Roosevelt Avenue to the south. One of the first areas to exclusively feature body shops and auto parts stores, it has been subject to eviction since the 1939–1940 New York World's Fair almost 70 years ago. This is looking north from Roosevelt Avenue under the elevated train of the No. 7 line.

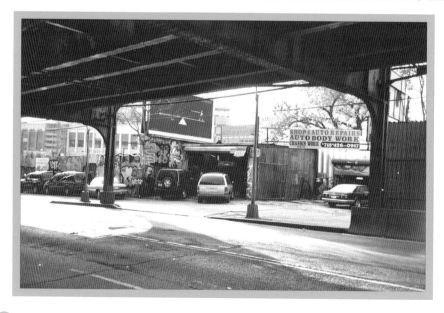

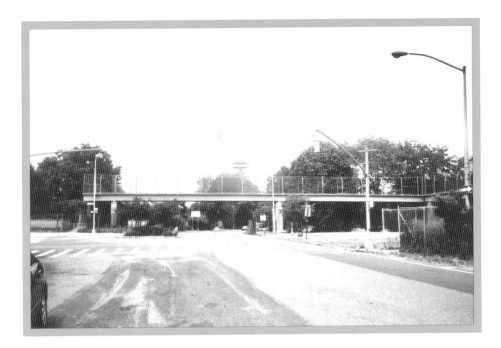

Corona Avenue in Corona is pictured just before the opening of the Grand Central Parkway in 1936. The street was divided for both commercial vehicle and trolley usage. Three gas stations, Sonoco, Shell, and Tydol are seen standing side by side. A sign in the foreground warns drivers to proceed with caution because of construction for the new parkway. The trolley tracks and gas stations disappeared when the street was later widened. In the background is the New York State Pavilion from the 1964–1965 New York World's Fair. (Courtesy of Culver City Pictures.)

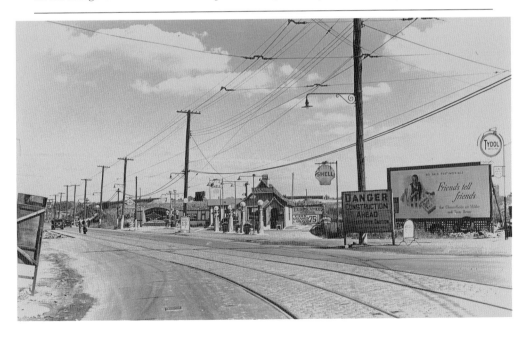

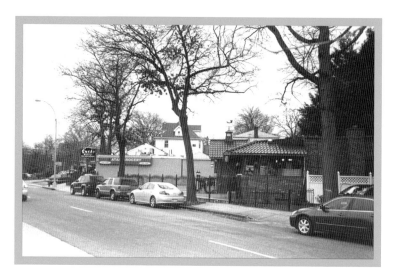

In 1938, Cross Island Boulevard was a small country road that traveled almost the entire length of Queens. Clark's Diner in Auburndale was set up as a roadside stop for people traveling south to the Rockaways. This two-lane road was one of the only ways to cross the borough from north to south. Routes like the Van Wyck Expressway and Interboro Parkway would not appear for another decade. In the late 1930s, the street was renamed Francis Lewis Boulevard after a signer of the Declaration of Independence from Whitestone.

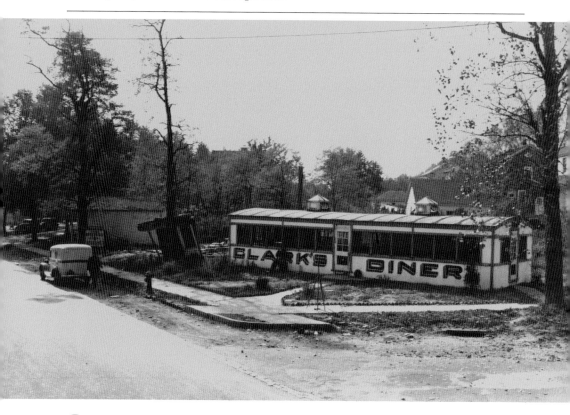

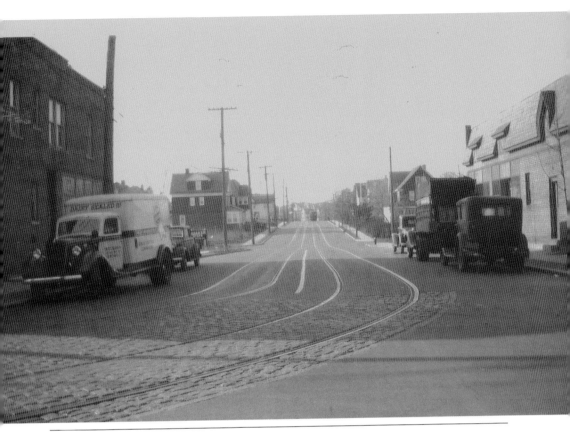

Trolley lines servicing the New York and Queens County Railway Company traveled north on 162nd Street, then made a left turn heading west on Forty-fifth Avenue in Flushing. This image is from the winter of 1937. Trolley service ended in Queens in 1937–1938. The unusual curve at this intersection is a result of the former trolley path.

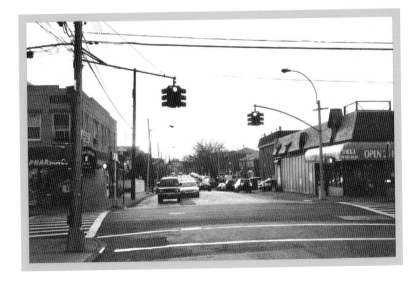

One of the most beautiful public schools built by the city, Flushing High School opened in January 1916. Built in the Gothic collegiate style usually reserved for colleges and universities, the school has been expanded several times. Famous alumni include restaurant giant Vincent Sardi Sr. and Jerry Bock, coauthor of the Broadway musical *Fiddler on the Roof.* Now draped in black tarp, the landmark-designated school is currently undergoing massive restoration work.

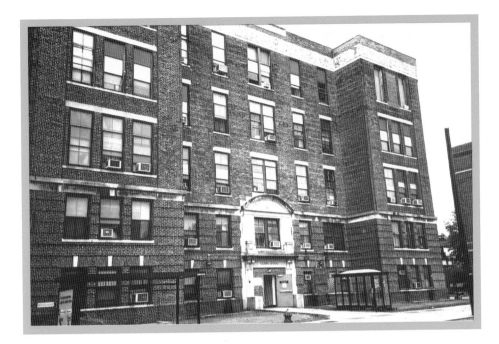

Flushing had the first hospital in Queens, which was originally located on Northern Boulevard. Flushing Hospital was built in 1887 on Forest Avenue, which is now Franconia Avenue and Parsons Boulevard. Unable to provide adequate care to the severely ill, the original wooden structure was torn down in 1910 and replaced by a modern five-story brick building. It too was finally expanded into Flushing Hospital Medical Center in 1930.

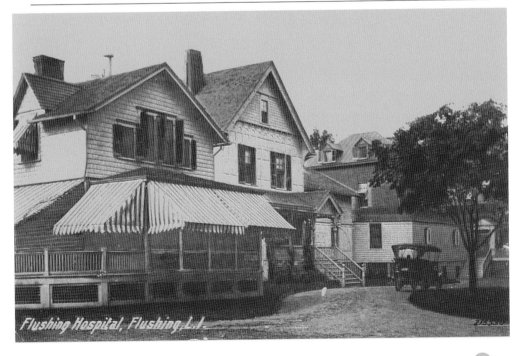

Flushing Hospital, Flushing, L.I.

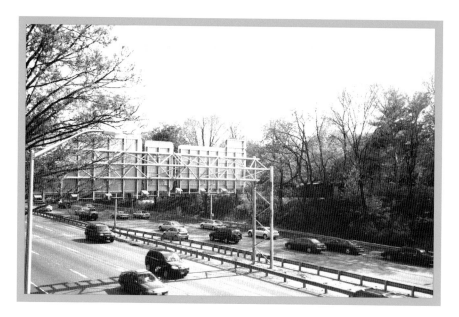

The 1964–1965 New York World's Fair was built in Flushing Meadows Park. It featured exhibits from around the world, including attractions built by major corporations such as U.S. Steel, IBM, and Kodak. Here at the pavilion for U.S. Royal Tires, visitors soared 80 feet into the air around a giant automobile tire above the Grand Central Parkway. Twenty-four gondolas seated four people each and moved around the circumference of the wheel. The area has now been completely overtaken by nature. (Courtesy of Bill Cotter.)

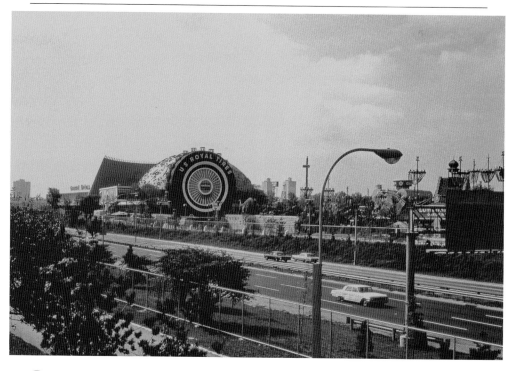

CENTRAL AND SOUTHERN QUEENS

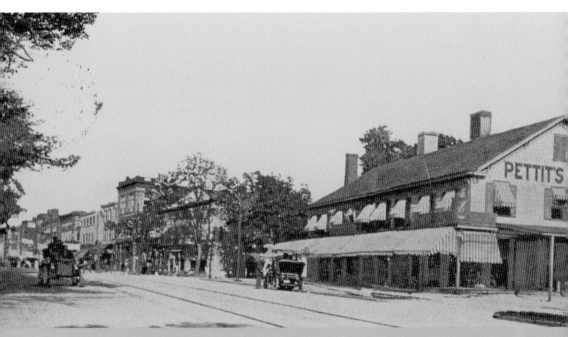

Central and southern Queens is dominated by Jamaica and the Rockaways, both with an enormous population. Now gone for over 100 years, Pettit's Hotel stood on Fulton Street (now Jamaica Avenue) near Parsons Boulevard. Pres. George Washington actually slept here in 1790, calling it in his diary "a pretty good and decent house." In the 19th century, the inn became a stagecoach terminal. Alonzo B. Pettit ran the hotel from 1870 to 1896. The hotel was demolished in 1906.

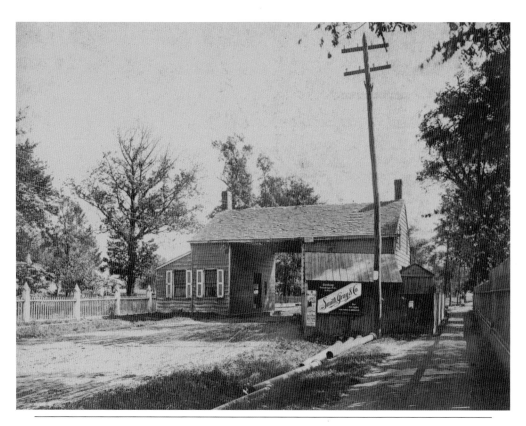

Located at Jamaica Avenue and Hemlock Street at the boundary of Queens and Brooklyn, this tollgate was one of many built in the 1800s by the Brooklyn, Flatbush, and Jamaica Plank Road Company. Tolls were collected from passing horses and stagecoaches. It was removed in 1897 when the elevated road servicing the J train of the Brooklyn–Manhattan Transit (BMT) Jamaica line was built. What an amazing contrast when compared to the Jamaica Avenue of 100 years ago.

CENTRAL AND SOUTHERN QUEENS

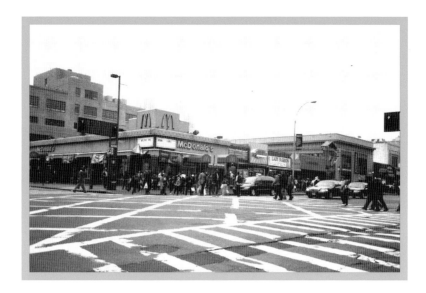

One of the original provinces, Jamaica is located at the geographical center of Queens. It became an important trading center for farmers and grew into a huge commercial district. Built in 1870, the Jamaica Town Hall located at Parsons Boulevard and Jamaica Avenue housed the municipal courthouse, sheriff's office, and traffic court. A Victorian-era structure with a mansard roof and multiple chimneys, it was torn down in 1941. A McDonald's now occupies the site. (Courtesy of the Queens Borough Public Library, Long Island Division, Frederick J. Weber photographs.)

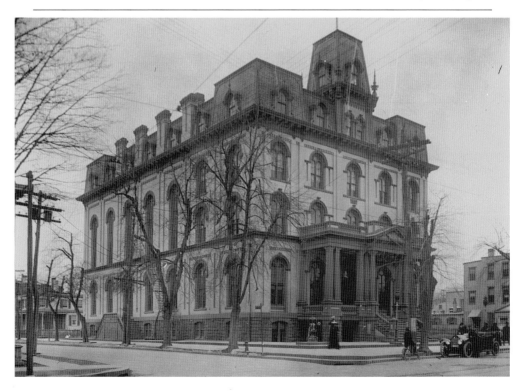

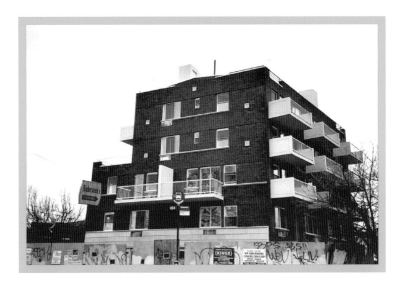

Niederstein's Restaurant was located at 69–16 Metropolitan Avenue near Sixty-ninth Street in Middle Village. Built by Henry Schumacher in 1854, it was originally called Schumacher's Lager Beer Saloon and Hotel. It became John Niederstein's Hotel and Restaurant in 1888. The hotel was used by travelers on old Jamaica Turnpike and by mourners attending funerals at Lutheran Cemetery across the street. In 1969, the front porch and carriage sheds were removed. Demolished in 2005, Niederstein's sign is all that remains of the 150-year-old structure. (Courtesy of the Queens Borough Public Library, Long Island Division, Eugene L. Armbruster photographs.)

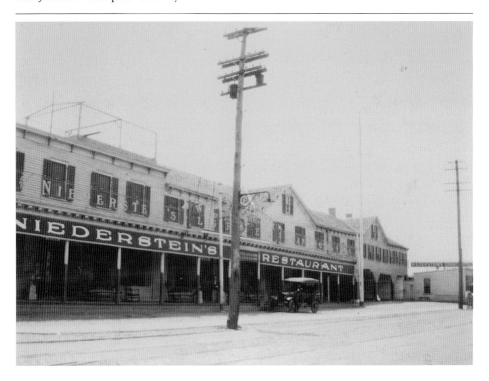

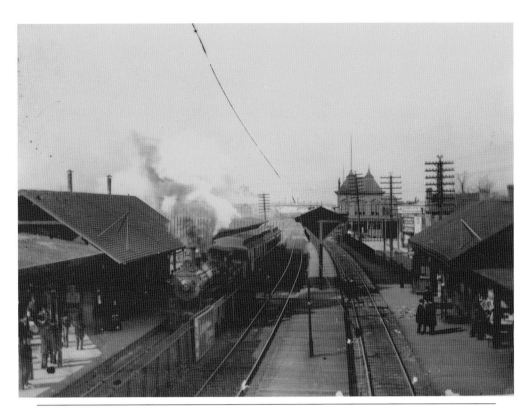

This is an amazing photograph from 1878 of the Long Island Rail Road station at Jamaica looking west. Smoke is billowing from the steam engine as it approaches the platform and a group of waiting passengers. This massive station complex, built in 1876, was located on 151st Street just south of Jamaica Avenue. By 1910, a new station was being built as the tracks became electrified and elevated, allowing vehicle traffic to pass below. (Courtesy of the Suffolk County Historical Society.)

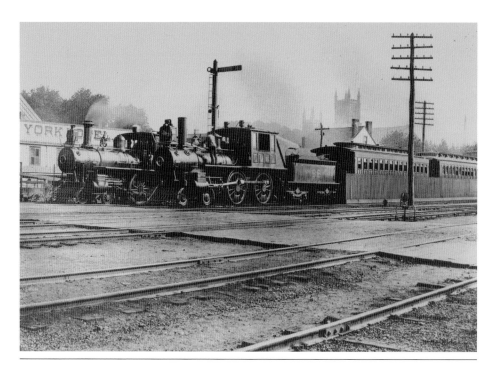

Another view of Jamaica Station in 1878 shows workmen servicing two huge steam engines. The trains are facing west, heading to Brooklyn and Long Island City. Behind the station and to the right are the bell towers of the First Reformed Church, built in 1858. The new station was completed in 1913 and expanded from 2001 until 2006. Today Jamaica Station is the largest hub on the Long Island Rail Road and one of the busiest stations in the country, servicing over 200,000 people daily.

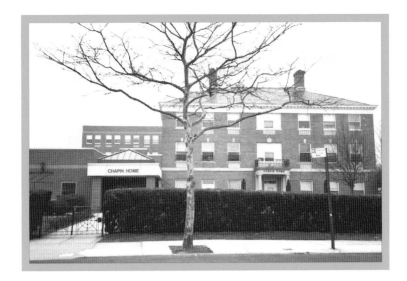

Located at 165–01 Chapin Parkway in Jamaica is the Chapin Home for the Aged and Infirm. Built for $152,800, it opened in the winter of 1912, as shown in this postcard image. Founded by the wife of Rev. E. H. Chapin, it housed 220 elderly residents who were charged $500 to be admitted. In the 1960s, the complex was completely refaced. It still stands today.

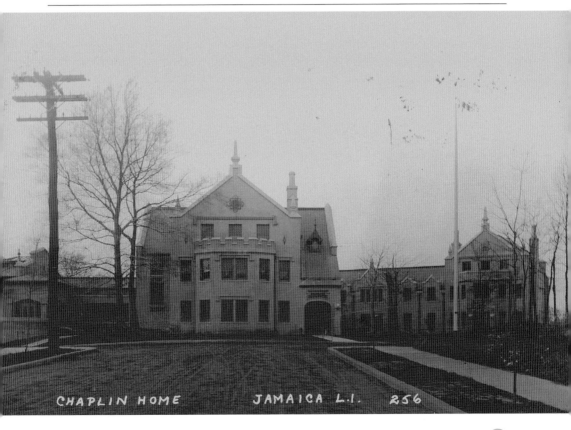

CHAPLIN HOME JAMAICA L.I. 256

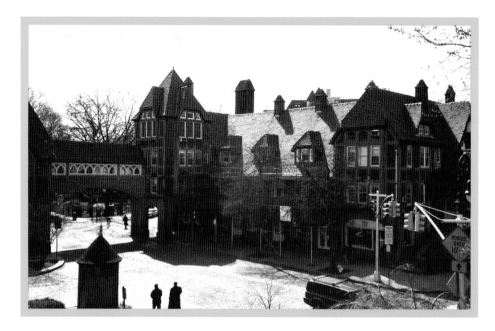

Forest Hills Gardens began with a purchase of 600 acres of farmland by the Cord Meyer Development Company. The first houses and new streets were laid out by 1908. That same year, Margaret Olivia Slocum Sage bought 160 acres. The Sage Foundation, which she started, created Forest Hills Gardens. Architect Frederick Law Olmsted and supervising architect Grosvenor Atterbury created the narrow, winding, privately owned streets. Forest Hills is one of the few neighborhoods in Queens that is in many ways untouched by time.

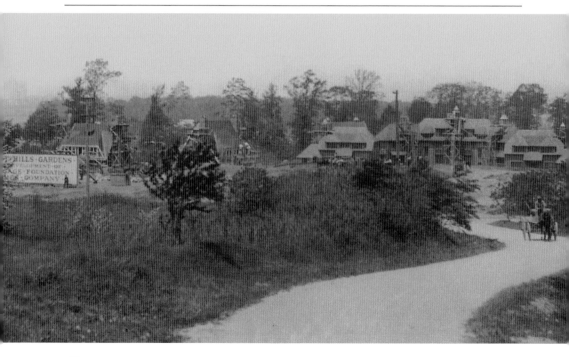

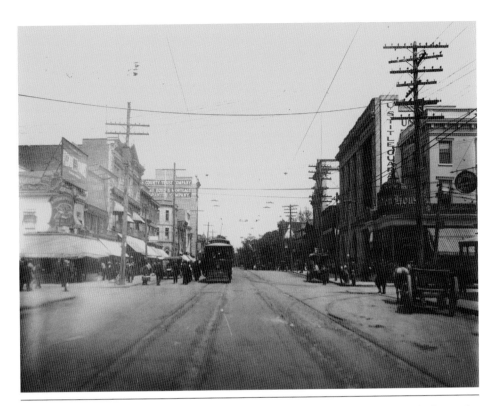

No where else is early-20th-century Queens better illustrated than in this photograph looking east on Jamaica Avenue, then known as Fulton Street, in the year 1912. Trolleys move on both sides of the street as horse-guided wagons deliver goods to local businesses. Electric wires that powered the trolley cars are suspended above the road. Saloons surround the 160th Street intersection offering Budweiser beer and Moerlein's Cincinnati Beer. Jamaica Avenue was originally called Kings Highway in the early 1800s.

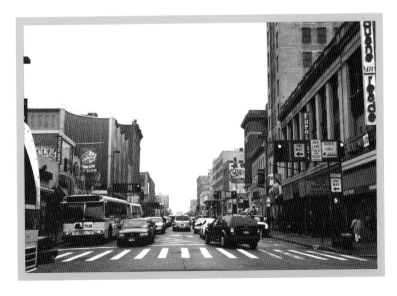

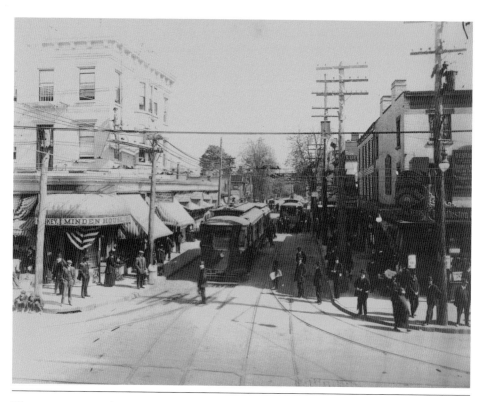

This view was taken looking south on 160th Street from Jamaica Avenue in 1912. Jamaica has always been a prime location for family-owned businesses. Saloons, restaurants, cafés, law offices, and general stores pack the street. The development of this huge commercial area resulted when Jamaica Station became a major hub after the line was elevated. It also acted as a depot where trolleys would depart heading east to Mineola in Long Island and north to Flushing. The intersection is now totally unrecognizable.

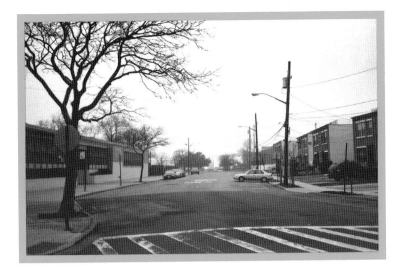

The Wainwright and Smith Fresh Water Showers and Hot Sea Water Baths Pavilion was located on Seaside Avenue in the Rockaways. The bathing pavilion, shown here in 1903, was one of many such pavilions that were owned by developer William Wainwright in Far Rockaway. These pavilions, including Healy's Ice Cream Parlor and Restaurant seen in the background on the left, were built entirely from wood and burned to the ground on May 13, 1911. Today Seaside Avenue, looking south, is just an ordinary side street.

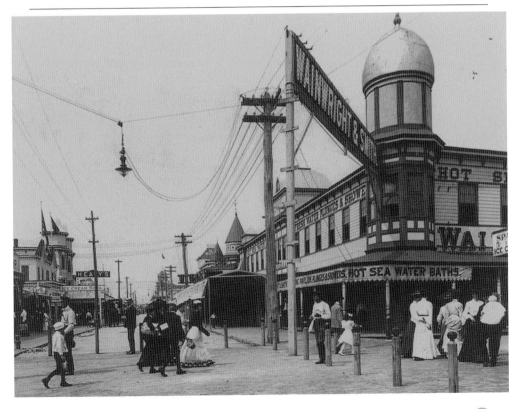

William Wainwright's Bathing Beach and Playland are pictured in 1906 looking east from Beach 103rd Street toward Wolz's Thriller Wood Coaster. This concession area was where bathers sat on the beach enjoying ice cream and hot dogs. This is also the former site of Rockaway Playland. It was all torn down by Robert Moses to build the Shore Front Parkway. The land is now used by the City of New York Rockaway Water Pollution Control Plant, which is controlled by the Department of Environmental Protection.

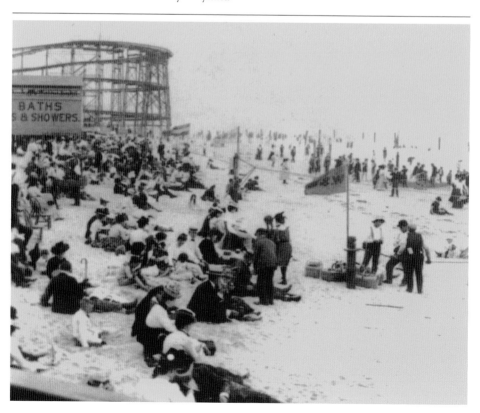

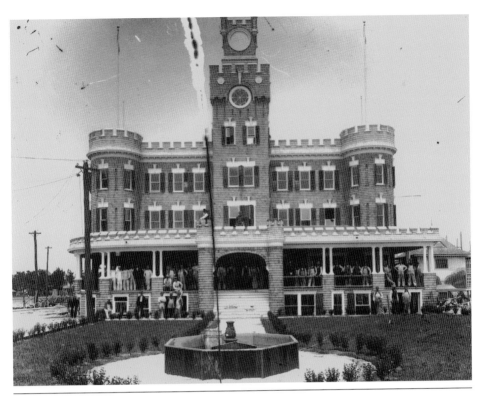

In this rare photograph from 1900, construction workers pose proudly before the newly completed Columbia Hotel. Owned by Herman G. Mertens, it was located on Beach Seventy-sixth Street, now Beach 104th Street, in Arverne. At 1:45 a.m. on January 17, 1905, the Columbia was destroyed along with the Waldorf and Shanley Hotels in an enormous flash fire. Rockaway became the Fifth Ward of Queens in 1898. A new gated community and the elevated A and S trains erase any trace of the former summer resort.

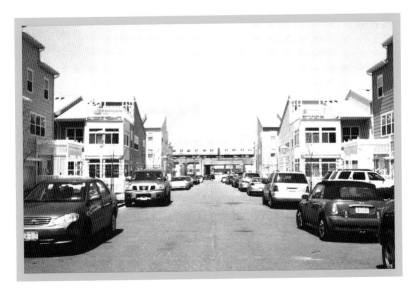

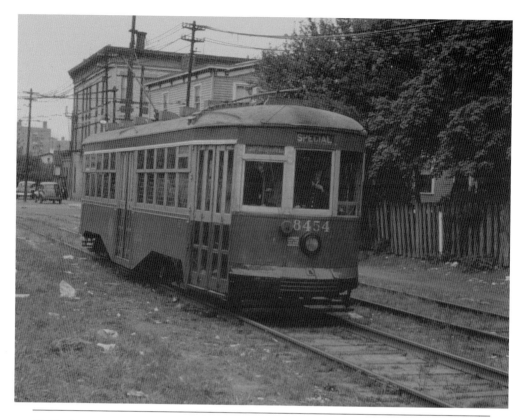

Trolley No. 8454 is pictured traveling down Madison Street and Woodward Avenue heading toward the Brooklyn and Queens border. It is now a ghostly reminder of the borough's lost trolley era. The old tracks and right-of-way, surrounded by the original cobblestone roadbed, ride off into oblivion. The tracks were originally for the Brooklyn Rapid Transit. In 1913, it was decided to elevate the train, leaving the tracks available for trolley use.

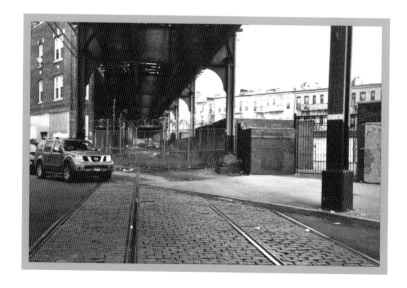

CHAPTER 4

EASTERN QUEENS AND BEYOND

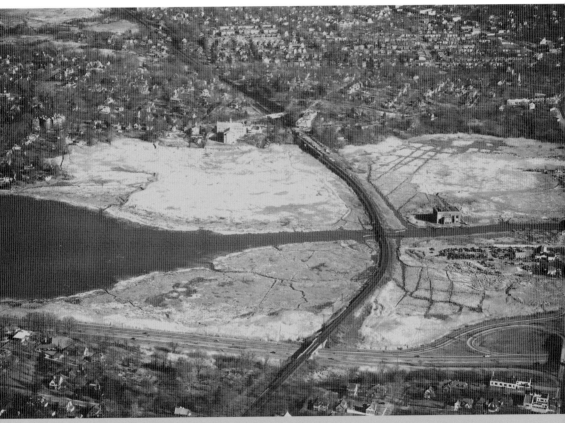

The territory of eastern Queens consists of Bayside, Douglaston, and Little Neck. The towns of Hempstead and Oyster Bay were once part of Queens as well. Nassau County was born out of the newly formed borough on January 1, 1899. The first settlers were the English, who arrived in 1640 on the North Shore after leaving the Massachusetts colony. The county was named Nassau in honor of William III of the Netherlands, who descended from the German House of Nassau. (Courtesy of Fairchild Aerial Surveys.)

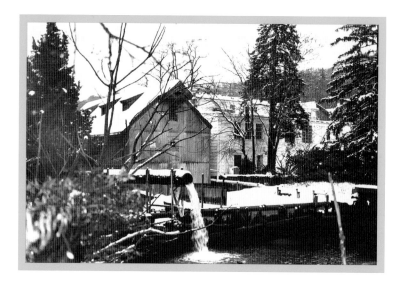

Originally called Hempstead Harbor, Roslyn was founded in 1643 by some of the first English colonists from New England. This gristmill was built in 1701. When George Washington passed through Roslyn during his tour of Long Island in 1790, the president mentioned in his diary the gristmill and its owner, Hendrick Onderdonk. In 1916, the gristmill was turned into a tearoom and featured a celebrity guest list that included Gloria Swanson. The gristmill was declared a landmark in the early 1960s. (Courtesy of the Library of Congress.)

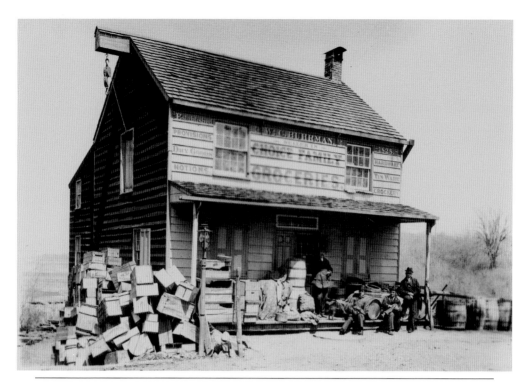

Benjamin Lowerre, a former innkeeper, built this house and general store in Alley Pond or "the Alley" in 1800. In 1821, it became the first post office for Flushing Village and the first trading post in northeastern Queens. Mail was brought by stagecoach, post rider, and boat. Lowerre sold it to his son-in-law William C. Buhrman in 1839. It was destroyed by fire on April 20, 1926, and is now the present site of the Long Island Expressway and Cross Island Parkway interchange. (Courtesy of the Queens Borough Public Library, Long Island Division, Hal B. Fullerton Collection.)

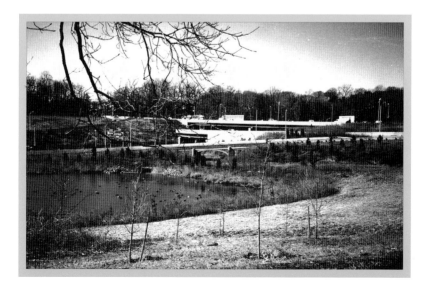

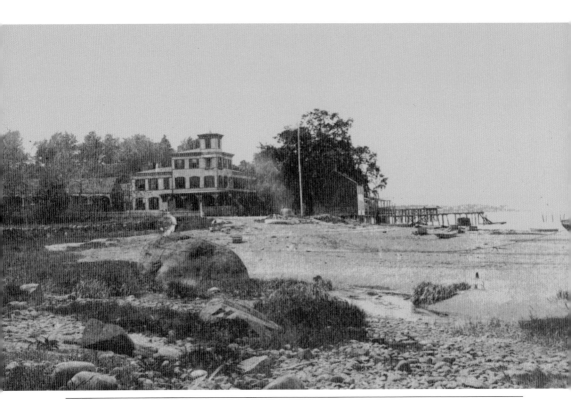

The Crocheron House was a waterfront hotel on Little Neck Bay in Bayside. Built in 1850 as Bayside House, it was renovated by Joseph Crocheron in 1865 and renamed. The hotel accommodated 50 guests and provided carriage sheds behind the structure. A popular resort, it was frequented by the infamous William "Boss" Tweed of Tammany Hall. According to legend, Tweed took refuge here after his escape from jail. The Crocheron House burned down in 1908 and is now the Cross Island Parkway. (Courtesy of the Bayside Historical Society.)

Originally called Willets Point Peninsula, land was purchased by the U.S. Army in 1857. Construction began in 1862 during the Civil War on what was formerly Charles Willets's farm. Barracks housed 3,000 troops, and in 1898, Pres. William McKinley renamed the base Fort Totten in honor of Maj. Gen. Joseph Totten. Shown here during World War I, Fort Totten served as a staging area for troops en route to Europe. After 100 years of service, Congress closed Fort Totten in September 1995.

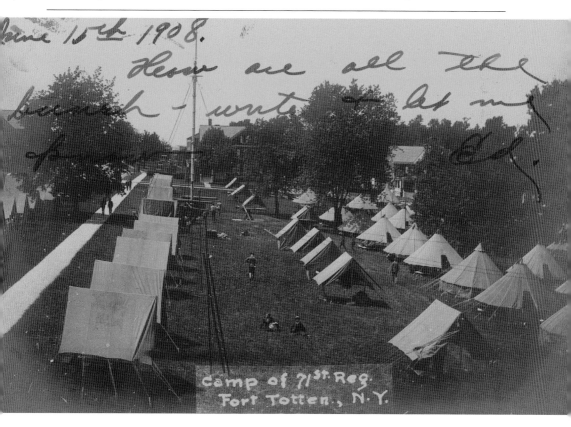

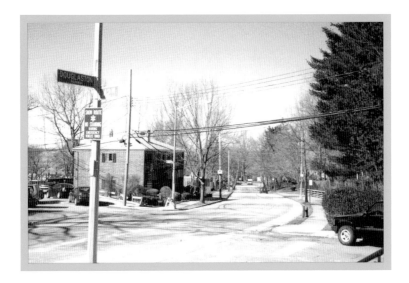

A man walks down a dirt-covered Main Avenue (Douglaston Parkway) on October 13, 1910. The old castlelike Public School 98 can be seen to the back left. Built in April 1887, the Douglaston station of the Long Island Rail Road's Port Washington branch is off to the right. In March 1962, the new station was built. Douglaston was named after developer William Douglas, who donated land for the first train station in 1866. The same view, looking north, shows the road now surrounded by homes. The tracks were depressed.

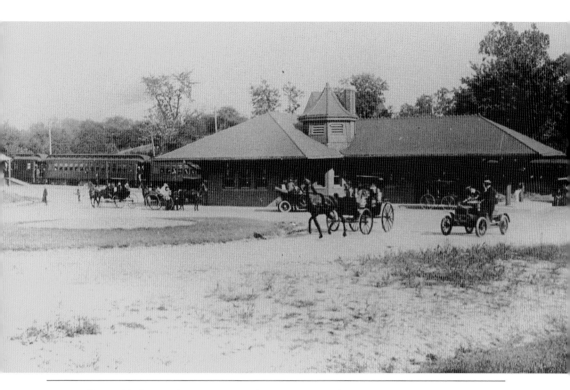

Originally called Musketa Cove, the city of Glen Cove, settled in the 1660s, was located in the town of Oyster Bay. The Glen Street station is seen in this postcard from 1905. The station opened on May 16, 1867, and services the Oyster Bay branch of the Long Island Rail Road. This station house was moved from across the street to its current location in 1888. It was listed as a New York State historic landmark in 1967.

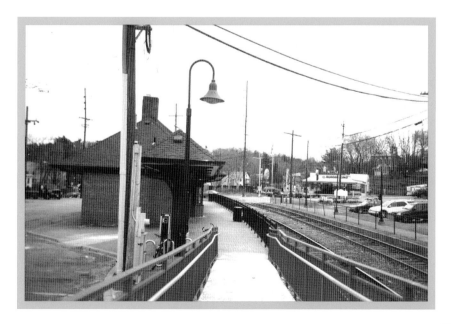

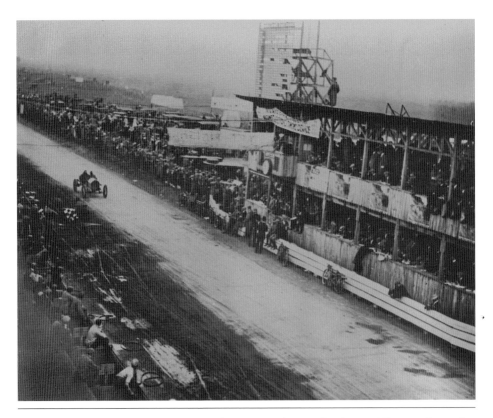

The territory of eastern Queens that is now Nassau County was home to the first automobile race in the United States, the Vanderbilt Cup, shown here in 1909. Developed by William Kissam Vanderbilt II, the Long Island Motor Parkway stretched 40 miles from Queens to Lake Ronkonkoma. This roadway also became the nation's first highway. In 1926, it was abandoned. This part of the former motor parkway, located at Skimmer Lane between Orchid Road and Woodcock Lane in Levittown, was the exact spot of the scene in the older photograph.

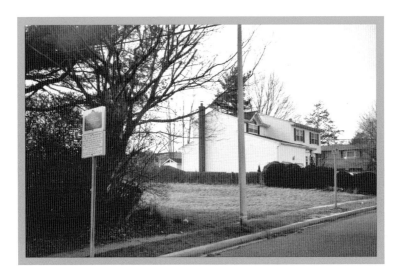

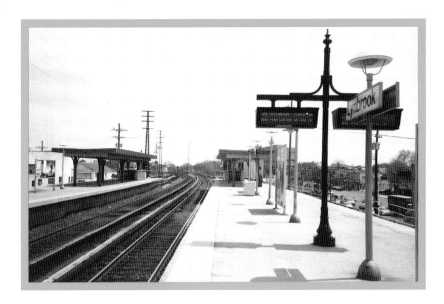

A trading route for hundreds of years by the Merrick Native Americans, it became known as Pearsall's Corners after successful general store owner Wright Pearsall. The village was renamed Lynbrook in 1911. The Lynbrook station was originally opened as Pearsall's Corner Station on October 28, 1867, by the South Side Railroad of Long Island. Rebuilt in 1881 and electrified on September 8, 1910, this third and current elevated station is located 1,113 feet west of its former location and was opened on October 18, 1938.

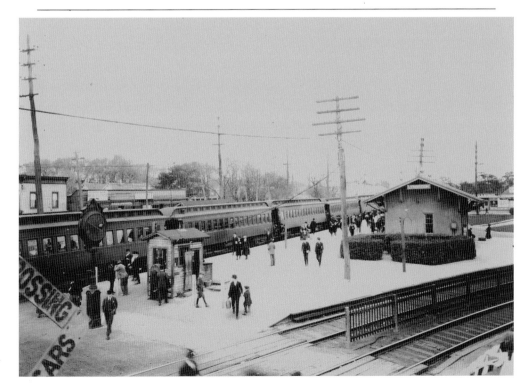

Garden City was settled on what was known as the Hempstead Plains by dry goods giant Alexander Turney Stewart in 1823. The enormous plain measured 16 miles long and 4 miles wide. The main strip located on Stewart Avenue is shown here in 1899, the year eastern Queens became Nassau County. Stewart Avenue extended west in 1880 for St. Paul's School. People in Victorian clothes can be seen strolling down the avenue at the edge of the open plain, which today has filled up considerably.

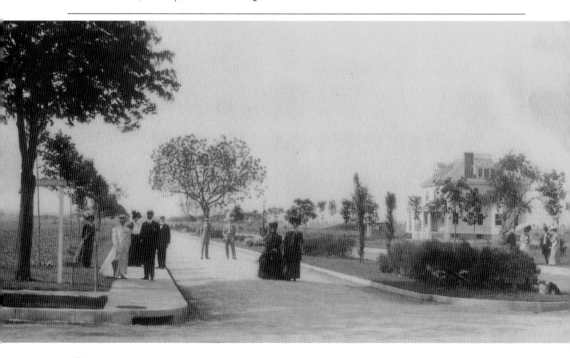

EASTERN QUEENS AND BEYOND

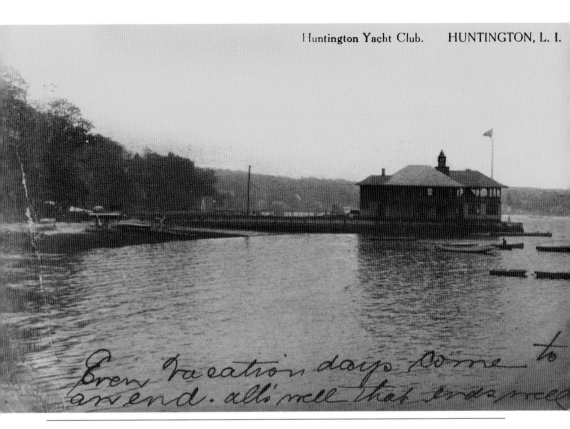

Even vacation days come to an end. All's well that ends well

The Town Endures is the motto of this area, which was first settled in 1653. The town of Huntington is located just over the Suffolk County border, the fourth and last county on Long Island. It was partially located in Queens County until 1900. The Huntington Yacht Club was organized by J. W. Shepard on September 15, 1894. The entrance fee was $25 with $15 yearly dues. Its mission was to create an interest in yachting and provide a harbor for its members.

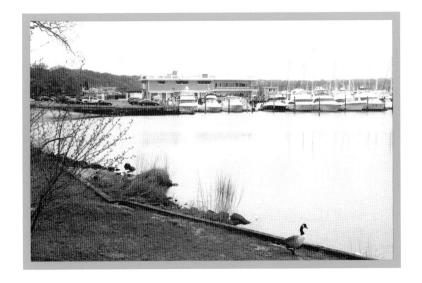

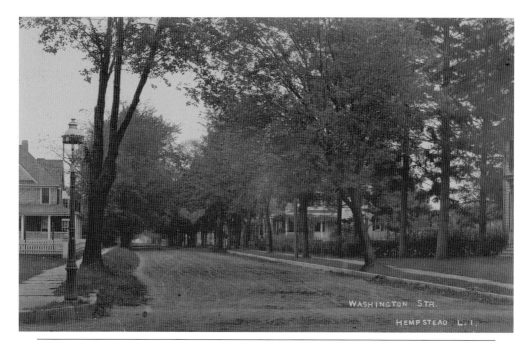

WASHINGTON STR.
HEMPSTEAD L. I.

Settled in 1644 by 50 English farmers with a patent by New Netherlands governor Willem Kieft, the Town of Hempstead was incorporated into Queens County in 1683. The birthplace of American aviation, Hempstead features Roosevelt Field from where Charles Lindbergh made the first solo transatlantic flight with the *Spirit of St. Louis* on May 21, 1927. This postcard scene shows the quiet residential Washington Street in 1915. The dirt road has been paved and widened while some of the original homes remain next to modern brick structures.

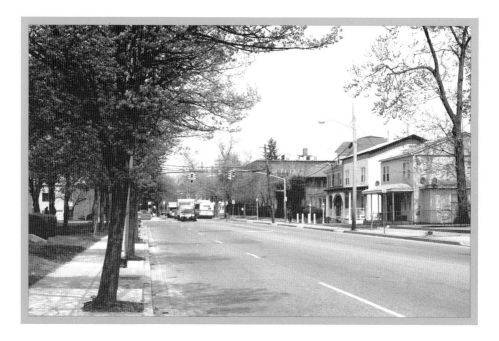

Located on Northern and Bell Boulevards in Bayside is the oldest standing White Castle in the country. Opening on September 10, 1932, as a small road stop offering its famous 10¢ hamburgers, it was remodeled and enlarged in the 1970s. This rare example shows how some things can remain the same, even in the borough of changes. America's oldest hamburger fast-food restaurant still runs all day, seven days a week, with the use of its drive-through window. (Courtesy of the Bayside Historical Society.)

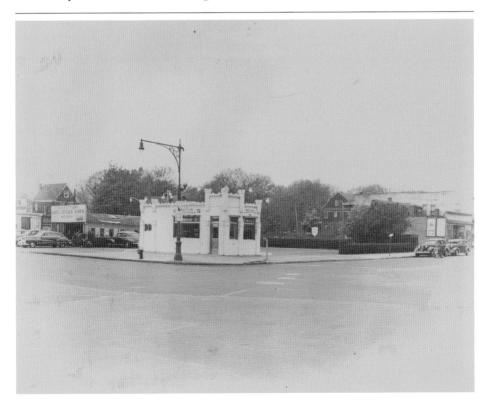

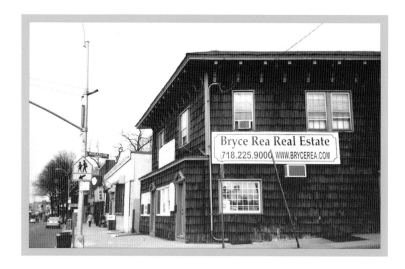

It was here, at the intersection of Northern Boulevard and Marathon Parkway, that Thomas Hicks and his force defeated Agawamonom, thus annihilating the last of the Matinecocks. The old Native American burial grounds, along with the remains of the Matinecock Native Americans, were unearthed when Northern Boulevard was widened for the 1939–1940 New York World's Fair. Their remains were buried at the Zion Episcopal Church in Douglaston. The intersection is now bordered by a Stop and Shop supermarket and Bryce Rea Real Estate. (Courtesy of the New York Daily News.)

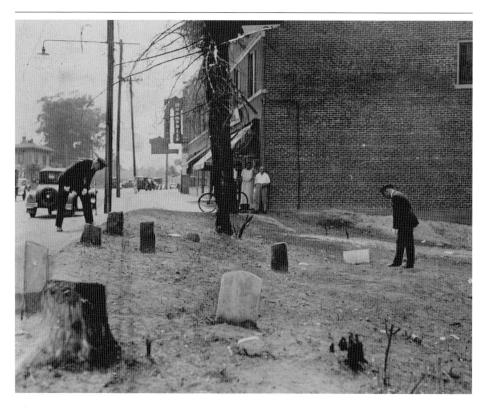

EASTERN QUEENS AND BEYOND

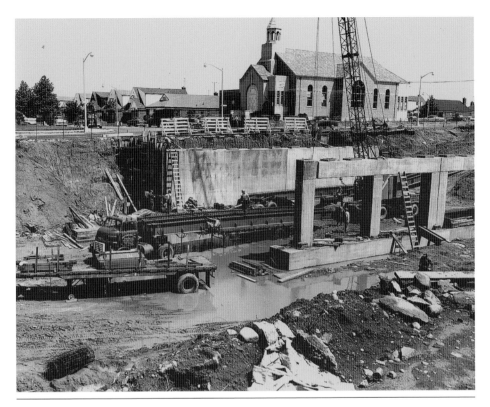

If the opening of the Queensboro Bridge marked the beginning of Queens' new frontier, then the Long Island Expressway has done the same for eastern Queens and Greater Long Island. Construction started at its western terminus in 1939 and opened to traffic in 1940 along with the Queens-Midtown Tunnel. After 33 years of delays and construction, as seen in this photograph near exit 32, the 71.02 miles of the Long Island Expressway reached its eastern terminus at Riverhead on June 28, 1972. (Courtesy of Newsday, Long Island, New York, photograph by Cathy Mahon.)

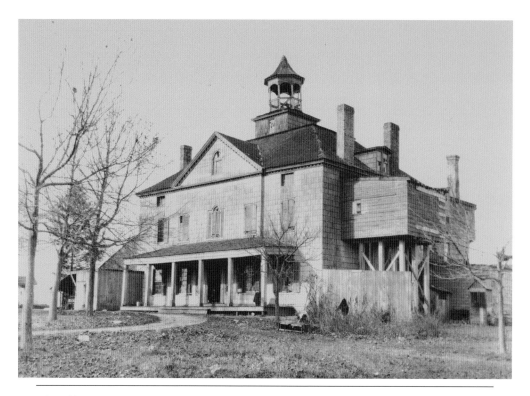

The old Queens County Court House in Mineola stood at the northwestern edge of the Hemsptead Plains. This three-story wooden behemoth was a major figure in the secession of Hemsptead, North Hempstead, and Oyster Bay in 1899, which created Nassau County. Defunct in 1900, it was used as an asylum and then accidentally burned down in 1903. Today a stone marker placed by the Long Island Bible Society marks the spot of the old courthouse now occupied by a Waldbaum's supermarket. (Courtesy of the Queens Borough Public Library, Long Island Division, Joseph Burt photographs.)

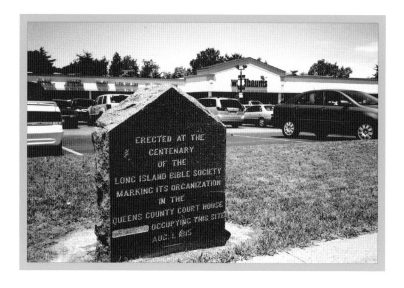

EASTERN QUEENS AND BEYOND

This short journey through Queens ends here at the Queens Center Mall in Elmhurst. Opening in 1972 on land previously occupied by a children's amusement park named Fairyland, it is one of the busiest malls in the country. Although situated in western Queens, this image of an old Victorian home holding out on the corner of Fifty-fifth Avenue is used to serve as a reminder of the forever-changing landscape of Queens. The home was destroyed shortly after this picture was taken. (Courtesy of the Queens Borough Public Library, Long Island Division, Illustrations Collection.)

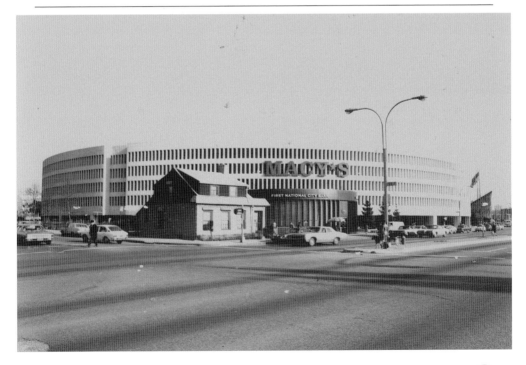

DISCOVER THOUSANDS OF LOCAL HISTORY BOOKS FEATURING MILLIONS OF VINTAGE IMAGES

Arcadia Publishing, the leading local history publisher in the United States, is committed to making history accessible and meaningful through publishing books that celebrate and preserve the heritage of America's people and places.

Find more books like this at
www.arcadiapublishing.com

Search for your hometown history, your old stomping grounds, and even your favorite sports team.